IMAGES IN THE
Margins

THE MEDIEVAL IMAGINATION

IMAGES IN THE Margins

MARGOT MCILWAIN NISHIMURA

THE J. PAUL GETTY MUSEUM
THE BRITISH LIBRARY

der: la su demā
cebida en oti-
rate qno qēē
podia gntey n
ono py razō d
mentes de pe
ute c
dema
on ot

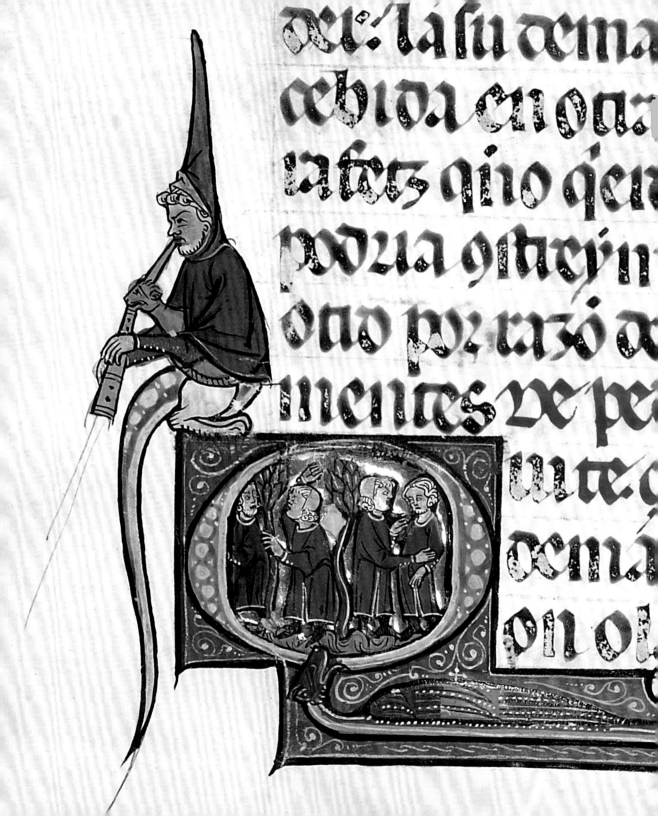

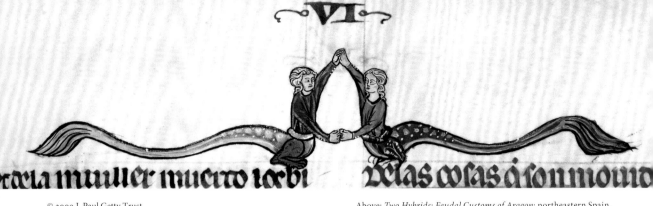

© 2009 J. Paul Getty Trust
Fourth printing

Published by the J. Paul Getty Museum, Los Angeles
Getty Publications
1200 Getty Center Drive, Suite 500
Los Angeles, California 90049-1682
getty.edu/publications

Elizabeth Morrison, *Series Editor*
Mollie Holtman, *Editor*
Robin H. Ray, *Copy Editor*
Kurt Hauser, *Designer*
Amita Molloy, *Production Coordinator*
Rebecca Vera-Martinez, *Photographer*

Distributed in the United States and Canada by the
University of Chicago Press

Distributed outside the United States and Canada by
Yale University Press, London

First published in Europe in 2009 by
The British Library
96 Euston Road
London NW1 2DB
www.bl.uk

Printed in China

Library of Congress Cataloging-in-Publication Data

Nishimura, Margot McIlwain.
 Images in the margins / Margot Mcilwain Nishimura.
 p. cm. — (Medieval imagination)
 ISBN 978-0-89236-982-9 (hardcover)
 1. Marginal illustrations. 2. Illumination of books and manuscripts,
Medieval. I. Title.
 ND3343.4.M38 2009
 745.6'7—dc22
 2009013998

British Library Cataloging-in-Publication Data
A catalogue record for this book is available from the British Library
ISBN 978-0-7123-5083-9

Above: *Two Hybrids; Feudal Customs of Aragon*; northeastern Spain, ca. 1290–1310. JPGM, Ms. Ludwig XIV 6, fol. 207.

Front cover: Detail of *A Fool Grimacing* (fig. 65).

Back cover: Detail of *Animals using Astronomical Instruments* (fig. 60).

Frontispiece: Detail of *A Hybrid Man* (fig. 50).

Sources for Quotations

Page 46: *Fasciculus Morum: A Fourteenth-Century Preacher's Handbook*, edition and translation by Siegfried Wenzel (University Park and London, 1989), p. 515.

Page 65: Lucy Freeman Sandler, "The Study of Marginal Imagery: Past, Present, and Future," *Studies in Iconography* 18 (1997), p. 40.

Author's Acknowledgments
My thanks to Thom Kren for inviting me to write this book; to Elizabeth Morrison, Mollie Holtman, and David Nishimura for helping to shape the text; to Kathryn A. Smith for answering my question; to my friends and family in Providence, Toledo, and elsewhere for their good humor; to Amelia, Louisa, and Cecily for being even more amusing than the margins; and to Lucy Sandler and the late Michael Camille for paving the way. I dedicate the book to Lilian Randall.

Note to the Reader: In the captions in this book, the title of the marginal image under discussion appears first, with the title of the main image on the manuscript page in brackets beneath it.

CONTENTS

yfon. at nr.

ue nos. ucr aia

mea et laudabit te.

FOREWORD

This third installment in the Medieval Imagination series takes as its topic the wonderful and often irreverent world of marginal imagery in manuscripts. As with its two predecessors in the series, the book is intended to evoke the rich and varied world of the Middle Ages as seen through the lens of manuscript illumination. The subject of this volume is particularly engaging, for it focuses the reader's attention not on the center of the manuscript page, but on what one sees at its outer edges, where legions of characters frolic. Sometimes the scenes in the margins comment upon or interact with the images or text found at the center of the page, but frequently the depictions seem to appear for the sheer joy of enlivening the design of the page and entertaining viewers. We are pleased to be able to collaborate with the British Library once again in presenting this newest addition to the series.

We thank Margot McIlwain Nishimura, an independent scholar who teaches medieval art at the Rhode Island School of Design, for her enchanting contribution to the series. We are also grateful to Elizabeth Morrison, curator of manuscripts at the Getty Museum and series editor, for her ongoing work to make the series possible. Rebecca Vera-Martinez completed the often-demanding photography for this project, and Michael Smith and Johana Herrera, as always, made the final digital files sparkle. Nancy Turner, Christine Sciacca, Kristen Collins, and Henrike Manuwald all contributed their valuable time to the process of photography. The series is the brainchild of Kurt Hauser, senior designer in Getty Publications; in this third volume he has successfully captured the richness of the material while maintaining a sense of its small scale. We also acknowledge Gregory Britton, Mark Greenberg, Mollie Holtman, Amita Molloy, Leslie Rollins, and Rob Flynn of Getty Publications, who all have enthusiastically devoted time and energy to this volume and to the series as a whole. We also recognize our colleagues at the British Library, including David Way and Sally Nicholls, who have been invaluable in making this series a success.

Thomas Kren
Senior Curator of Manuscripts
The J. Paul Getty Museum

Scot McKendrick
Head of Western Manuscripts
The British Library

High above the streets of Paris

loom the gargoyles of Notre Dame Cathedral. Although they are romantic nineteenth-century re-creations, their presence is an echo of a genuinely medieval practice. Such wickedly delightful forms were not exclusive to cathedral rooflines, however, and in the margins of illuminated manuscripts lie a world of inviting images equally at odds with the solemnity of their settings. Trade binoculars for a magnifying glass, and you will find a surprisingly fresh array of the fantastic, the real, and the ridiculous among the images in the margins.

Gargoyle, Notre Dame, Paris
Designed by Eugène Emmanuel
Viollet-le-Duc, ca. 1845–64
Unknown photographer
Paris, ca. 1870
Albumen silver print
JPGM, 84.XP.492.14

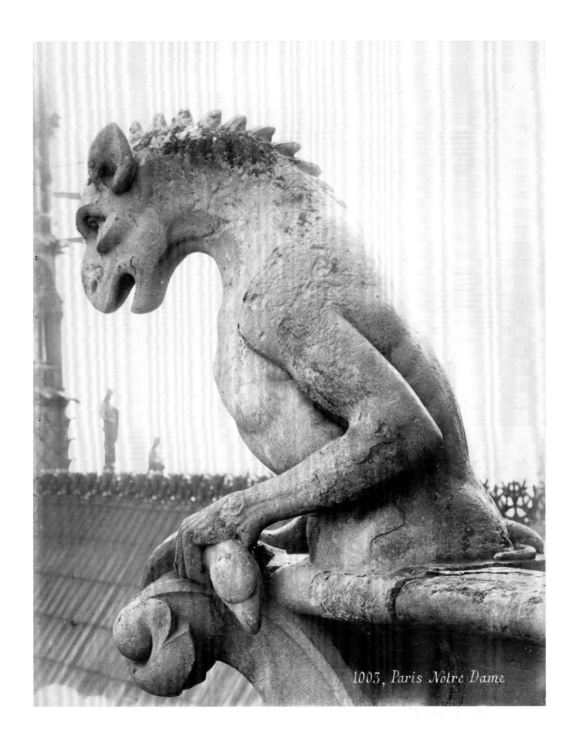

1003, Paris Notre Dame

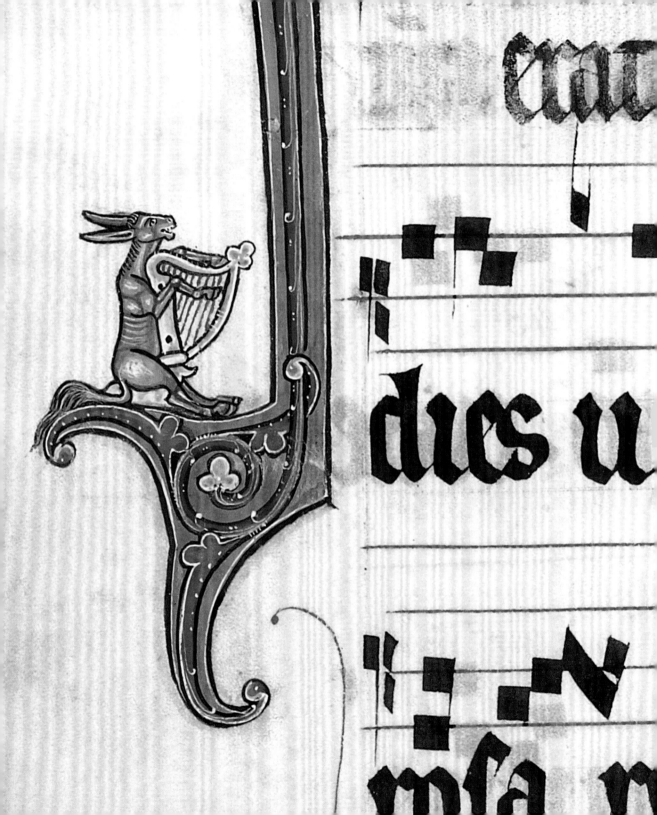

INTRODUCTION

"Marginalia" is a modern term that refers to words or images in the margins of a page. It is derived from Latin, meaning "things in the margins." Marginalia were especially common in English, French, and Italian manuscripts of the thirteenth and fourteenth centuries (called the Gothic era). Around the middle of the thirteenth century, we begin to see single and paired figures, and the occasional minimal scene, in the otherwise empty spaces of the page, outside the area where the text was written. By the early fourteenth century, there are so many images in the margins that they must have become an expected feature and a desirable complement to the more conventional elements of the manuscript page: miniatures (independent scenes painted in a manuscript), historiated initials (large letters containing figures or small scenes), and ornamental borders.

Marginalia were usually designed by the artists who executed the rest of the decoration in a manuscript. In most cases, they were painted using an identical technique and the same materials as the other images on the page, and their subjects were drawn from a limited and predictable range of scenes and figure types that repeat from one manuscript to the next. We know, therefore, that they were purposeful elements of the design rather than simply spontaneous "doodles." But the rationale that governed their placement appears to have been every bit as whimsical as their subject matter. On one page, the marginalia might appear to have escaped from a scene in a miniature; on another page, they correspond to a word or phrase in the text; while on a third page, even in the same manuscript, there is no immediately identifiable relationship to either the text or the other images.

Unpredictable, topical, and often irreverent, like the *New Yorker* cartoons of today, marginalia must have been a source of great delight for medieval readers. Who wouldn't smile at the sight—regardless of whether it related to anything else on the page—of a donkey singing joyfully to some unknown tune plucked from the lyre in his lap (fig. 1), or a fool, naked below the waist, looking at us and pulling his mouth into a devilish grin (*see* cover)? And who wouldn't marvel at hybrid creatures (*see* fig. 48) so difficult to categorize that they have often simply been identified as "nondescripts"? But more difficult to answer is why this kind of droll medieval imagery occurs primarily in sacred contexts. For while there are marginalia in secular manuscripts—texts of astronomy (fig. 60), medicine, law (figs. 2, 10, 11, and 63) and both historical and romantic literature—they appear more often and in the largest numbers in books for Christian worship.

Fig. 1 ◁
**A Donkey Playing
a Lyre and Singing**
Antiphonal
Northeastern France
or Flanders,
ca. 1260–70
JPGM, Ms. 44/
Ludwig VI 5, p. 115

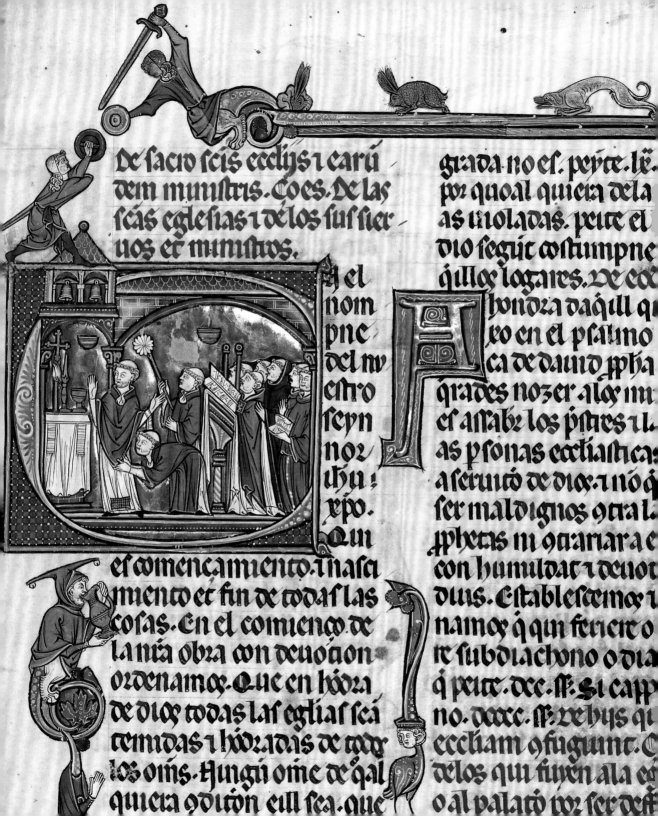

de ſacro ſcis ecclijs z earū
dem miniſtris. Co es. De las
ſcas egleſias z delos ſus ſier
uos er miniſtros.

grada no es. peyte. lê
por qual quiera dela
as uioladas. peite el
dio ſegut coſtumpne
qū llos logares. De cõ
hondza daqll q
xo en el pſalmo
ca de dauid ppha
grades nozer alos mi
er aſſabe los pſtres u
as pſonas eccliaſticas
a ſeruicõ de dios. z no q̄
ſer maldignos otra l
pphetas in orariara e
con humildat z deuot
dius. Eſtableſcemos i
namos q̄ qui feriere o
re ſubdiachono o dia
q̄ peite. Dcc. ſſ. Si cap
no. Dccc. ſſ. Rebys q̄
ecctiam oſuguunt.
delos qui fuyen ala e
o al palaciõ por ſer de

el
nom
pne
del nu
eſtro
ſeyn
nor
ihu
xpo.
Qui

es comencamiento. z naſci
miento er fin de todas las
coſas. En el comienco de
la nra obra con deuocion
ordenamos. Que en hõdza
de dios todas las egtias ſea
temidas z hõdzadas de todi
los omns. Hungu omne de qal
quiera ðditõ eull ſea. que

If you are like most modern viewers, you probably would not expect to see this kind of image in such solemn books. But there they are alongside Christian prayers: women churning butter, men harvesting and winnowing wheat, a noble lord hunting deer, hounds chasing their quarry, knights engaged in combat; and this is just a small sampling of one kind of image—scenes of everyday life—that abound in the margins. What about a quack monkey analyzing the urine of a duck (fig. 23)? What are we to think about scenes that openly mock the very practice of religion for which these manuscripts were made (fig. 2)? The images in the margins betray a culture surprisingly at ease with the mingling of the sacred and profane. This was a culture dominated by the Christian Church, but it was not without merriment, often provided by minstrels, comic poets, and writers of parody, whose subjects have many parallels with those in marginalia.

Throughout this book you will find many images that will reward a close and careful second look. In the typical late-medieval border seen in figure 2, in which one design element morphs into another to create a chain of activity, it is worth paying attention, for example, to the two creatures in the left margin under the very large letter *C*. The lower figure clasps its hands in prayer, which can be read as a mocking reference to the attitudes of the priests at a celebration of the Catholic Mass in the interior of the large initial letter. This figure has no head, but in its place is a curling vine that becomes the tail of the second figure—half human, half animal—wearing a fool's cap (note the bells on the tips) and slurping from a large serving pitcher. In contrast to the hallowed setting depicted immediately above, the world conjured up by this figure—especially with its noisy costume and unrefined behavior—is that of medieval inns, festive carnivals, and market fairs.

No one explanation satisfies our desire to find meaning in these out-of-the-way and sometimes ribald images. What follows in this book, then, is a kind of illustrated guide to the physical arrangements and subjects of marginal images, and what those images might have meant to the medieval viewer. It begins by examining the evolving role of marginalia in the design of the medieval page, continues with a closer look at some of the most common themes, and then considers specifically how images in the margins connected to the text, to other scenes in the same book, and to the world beyond the pages of the manuscript. So varied are the references, in fact, that if any universal can be claimed for marginalia, it is that they served many, often overlapping, purposes, not the least being to engage, enlighten, and entertain the reader, whether medieval or modern.

Fig. 2 ◁
Men, Hybrids, and Animals
[Initial C: A Priest Celebrating Mass]
Feudal Customs of Aragon
Northeastern Spain, ca. 1290–1310
JPGM, Ms. Ludwig XIV 6, fol. 9

THE MEDIEVAL PAGE

INHABITED INITIALS

Ironically, if you want to see where marginal images come from, you have to start by looking at the center—or rather within the text itself—of much earlier medieval manuscript pages. It was the fashion for illuminators of the tenth through twelfth centuries to indicate important divisions within the text with elaborately decorated initial letters that are literally "inhabited" by a varied cast of human and animal characters. Because they establish many of the forms and themes that appear in the margins of later books, these inhabited initials are important for tracing the development of marginalia. The secular subjects set a precedent for the inclusion of scenes of everyday life, animal tales, and monstrous beings in the margins of later manuscripts. And the delightful treatment of vines in the initials, as if they were real plants with a three-dimensional presence, greatly influenced the design of later borders.

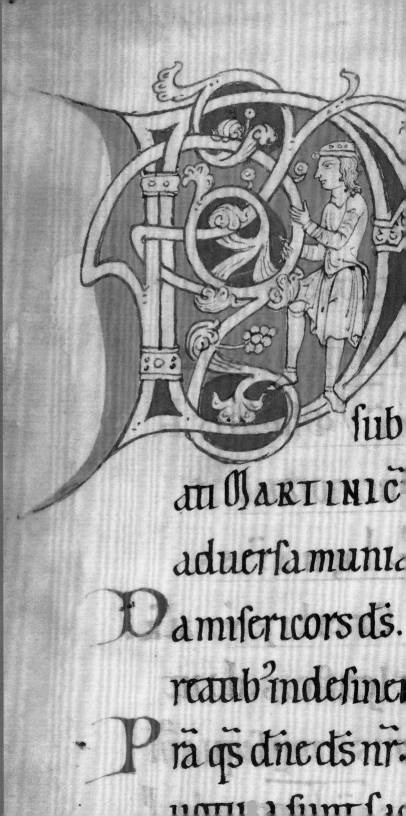

Fig. 3 ▷
Inhabited Initial *D*
Leaf from a sacramentary
Southwestern Germany or Switzerland,
last third of the twelfth century
JPGM, Ms. Ludwig V 3, recto

This large inhabited initial *D* introduces the text for the prayers recited on the feast day for Saint Martin of Tours (November 11). There is no reason, however, to connect the figure within the initial to the saint or his prayer. He has no halo to signify holiness, nor is he dressed in the clerical or military costume in which Saint Martin is usually shown. Instead, he wears the belted tunic and close-fitting cap of a contemporary artisan or craftsman, and he treats the meandering vines that surround him like a blackberry thicket needing careful negotiation. By drawing the figure's hands as if he were grasping a real branch, the artist has added a bit of visual whimsy to the experience of reading this page.

Fig. 4 ▷
Inhabited Initial *D*
Attributed to Nivardus of Milan
Sacramentary
Fleury, first quarter of the eleventh century
PGM, Ms. Ludwig V 1, fol. 9

The visual whimsy is even more charming in this initial, in which two boys clamber through gilt and silver branches that extend from a golden knot-work *D*. The boys are dressed like the figure in the *D* for the prayer of Saint Martin (fig. 3), with the addition of decorated collars, cuffs, and leggings, perhaps to associate them with the children of nobility educated at the wealthy Benedictine Abbey of Fleury, in Saint-Benoît-sur-Loire, where the manuscript was made. The struggle to get and stay aloft is convincingly expressed in the way the boy on the left wraps his right leg around the stem, tucks his foot under the nearest branch, and hangs on with elbow and armpit as he surveys the now greatly expanded world around him. Again, there is nothing to connect these boys to the theme of the text, but in their outward movements, away from the initial *D*, they herald the development of marginal images that are free from the confines of the space where the text was written.

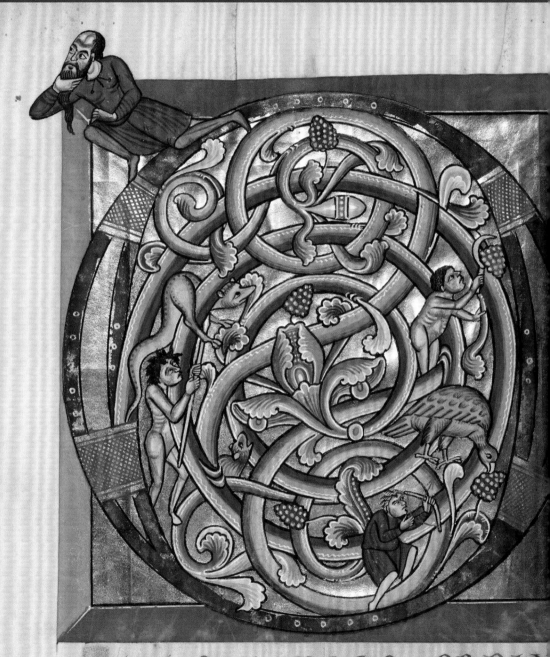

Fig. 5 ◁
Inhabited Initial *D*
Stammheim Missal
Hildesheim, ca. 1170s
JPGM, Ms. 64, fol. 152v

Sometimes the figures of inhabited initials
have a symbolic connection to the text.
Such is the case with the men hunting
a bird, spearing a serpent, and stealing
grapes within the sumptuous and colorful
vines of this initial *D* from the Stammheim
Missal. As common metaphors for
temptation and sin, familiar to the reader
from visual and literary traditions, these
figures embody the moral dangers referred
to only generally in the adjacent prayer—
an invocation to the angels to "keep our
lives safe from all harm on earth." The
naked and disheveled man at the lower
left is reduced to this state by his constant
struggle against the serpent, a common
symbol of the devil, while a second naked
man, depicted in the act of thieving,
exemplifies the sin of greed.

Fig. 6 ▷
Initial *S*: A Dragon and Rider
Psalter
Würzburg, ca. 1240–50
JPGM, Ms. Ludwig VIII 2, fol. 76

Here is an example of how later medieval
artists capitalized on the symbolic poten-
tial of inhabited initials. The illuminator
has shaped the dragon into an *S* and used
the struggle of the half-naked man to echo
the theme of suffering in the opening lines
of Psalm 68 directly below: "Save me, O
God, for the waters have come in even unto
my soul."

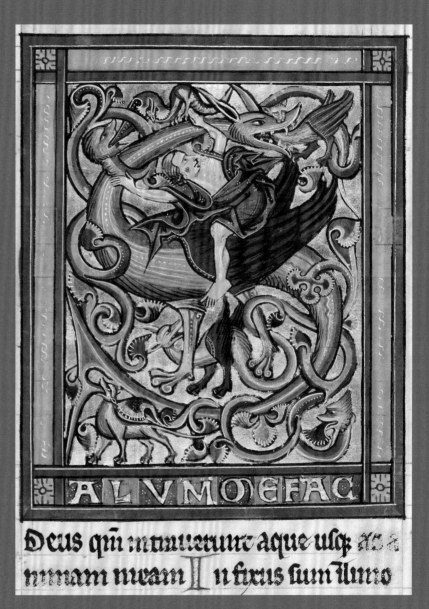

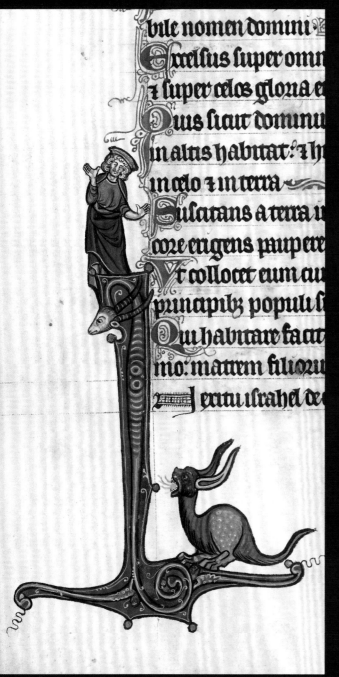

BORDERS

Marginalia are in many ways the by-product of thirteenth-century experimentation with the design of the manuscript page, especially in psalters (a compendium of the 150 biblical psalms), which were being made in large numbers for an increasingly literate population. To the visual scheme found in earlier manuscripts, illuminators added a new twist: at the most significant textual divisions they began to extend the decoration of the large initial letters into the margins to create elaborate borders. As the vines and branches of the earlier initials unraveled, as it were, the inhabitants escaped, and we begin to see dragons, men, and other creatures in the margins, interacting both with the new borders and with one another. To introduce the text, illuminators now inserted large "historiated" initials with fully painted narrative scenes or figures that relate to the content of the text.

Fig. 7 ◁
A Man Alarmed by a Fire-Breathing Dragon
[Inhabited Initial *I*]
Bute Master
Bute Psalter
Northeastern France, ca. 1270–80
JPGM, Ms. 46, fol. 164v

The illuminator of this psalter included marginalia at the openings to almost every one of the 150 psalms, not just at the most important divisions. At Psalm 112 there is no decorated border, but a man and a fire-breathing dragon find easy perches on the extensions to the elaborate letter *I* formed by the vertical body of a serpent with the head of a gazelle. Their relative positions were likely suggested by the verse adjacent to the man's head, which speaks of God "look(ing) far down upon the heavens and the earth."

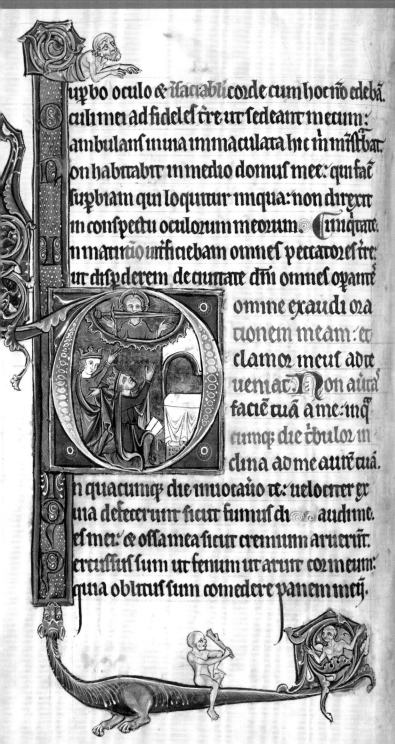

Fig. 8 ◁
A Dragon and Naked Men
[Initial *D*: Queen and King Praying to Christ]
Rutland Psalter
England, ca. 1260
BL, Add. Ms. 62925, fol. 99v

This page has a typical layout for important divisions within Gothic psalters. A large historiated initial and a decorative border alert the reader to a significant break in the text at Psalm 101. The *D* illustrates the opening lines, "Hear, O Lord, my prayer and let my cry come to thee," with a narrative scene of a king and queen praying to Christ (the sword in his mouth is described in the book of Revelation, 1:16). The kinds of combatants that were seen in the inhabited initials of earlier manuscripts (*see* figs. 5 and 6) have moved to the lower margin. Here two naked men frolic on the back and within the leafy tail of a dragon, which doubles as an extension of the border.

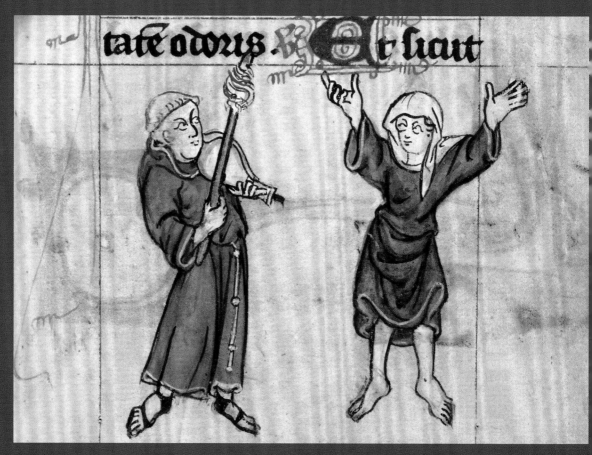

Fig. 9 △
A Friar Dancing with a Nun
Book of hours
Southern Netherlands (Liège), ca. 1310–20
BL, Stowe Ms. 17, fol. 38

While you are most likely to find margi-
nalia on pages with other illumination,
such as historiated initials and borders,
in many manuscripts they are also found
on their own. In this tiny prayer book, a
vast array of subjects occupies the larger
blank areas at the bottom of most pages.
The visual appeal of these marginal
images is especially direct in the absence
of competition from the foliate borders
seen in other manuscripts, and the fresh-
ness of the humor cuts across the ages.
Note how the nun here has tucked up her
habit well above her knees to dance to the
friar's "music"; he is playing a fireplace
bellows with a distaff (a wool-working tool)
— the medieval equivalent of a modern
"air guitar."

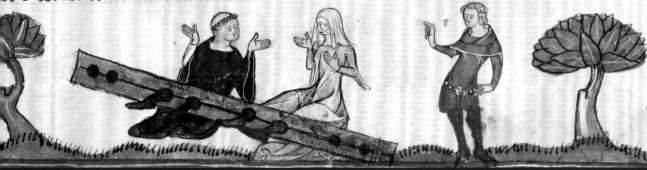

BAS-DE-PAGE SCENES

One space that was often given special attention in the design of margins and borders was the *bas-de-page* (French for "bottom of the page"). The area was usually created by dropping the lower horizontal bar of the border to well below the last line of text, leaving a substantial space set apart visually from the rest of the margin. Here we are more likely to find narrative scenes involving multiple figures, including fully conceived details of a setting, and—in a handful of English manuscripts—stories that continue in comic-strip fashion from one page to the next (figs. 10 and 11). Many *bas-de-page* scenes are recognizable from popular visual or literary traditions; others appear to be newly conceived for the specifics of the given page or pages.

Fig. 10 △
A Monk and a Noble Lady in Stocks
Smithfield Decretals
France and England, ca. 1300–40
BL, Royal Ms. 10 E.IV, fol. 187

Here are two *bas-de-page* scenes from a series that depicts a rather surprising, miraculous rescue. In the first image, a monk and a lady are locked in the village stocks as a punishment for adultery. Hearing in their prayers for deliverance a willingness to repent, the Virgin Mary releases the couple and replaces them with two devils.

Fig. 11 ◁
A Monk and a Noble Lady Replaced in the Stocks by Two Devils
BL, Royal Ms. 10 E.IV, fol. 188v

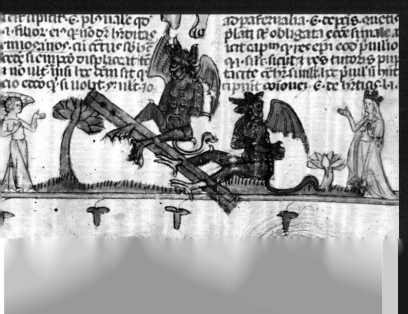

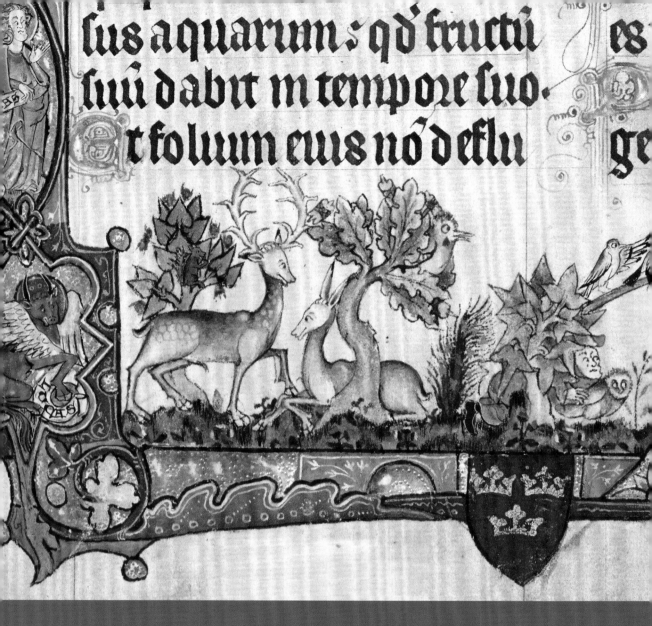

lius aquarum: qd̃ fructũ
ſuũ dabit in tempore ſuo.
Et foliũ eius nõ deflu

Fig. 12 △
Bird-Trapping in a Woodland Setting
Howard Psalter
England, early 1300s
BL, Arundel Ms. 83, fol. 14

Trouble lurks in the idyllic countryside of this *bas-de-page* scene, in which the magpie (far right) cries out to his fellow birds to beware the ruse of a convenient perch, which is really a sticky trap. It was set by the man hiding behind the clump of ivy at the center and clutching an owl —

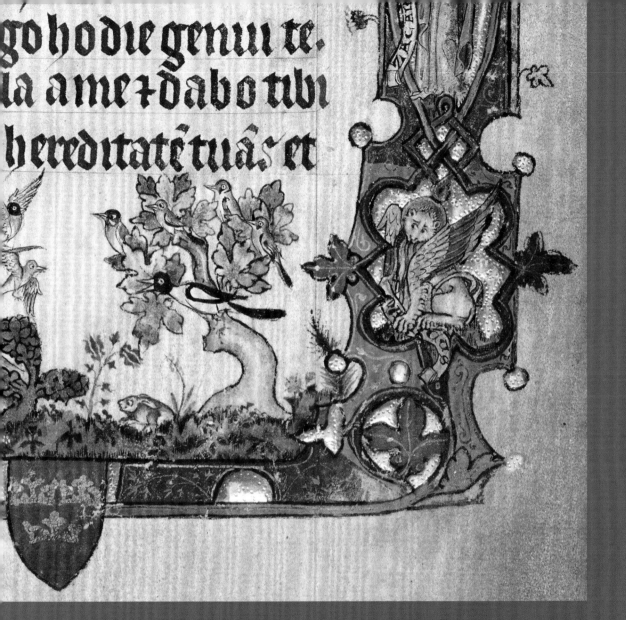

go hodie genui te.
la a me ⁊ dabo tibi
hereditatē tuā⸗ et

a common birding decoy in the Middle Ages. In this case the artist has taken as much care drawing the landscape as the birds, deer, squirrels, rabbits, and camouflaged hunter that inhabit it. The idea of hidden danger fits this location particularly well. It appears at the bottom of the first page of the first psalm, which begins, "Blessed is the man who has not walked in the counsel of the ungodly." It thus reinforces one of the most common themes of these ancient prayers: the battle of good versus evil.

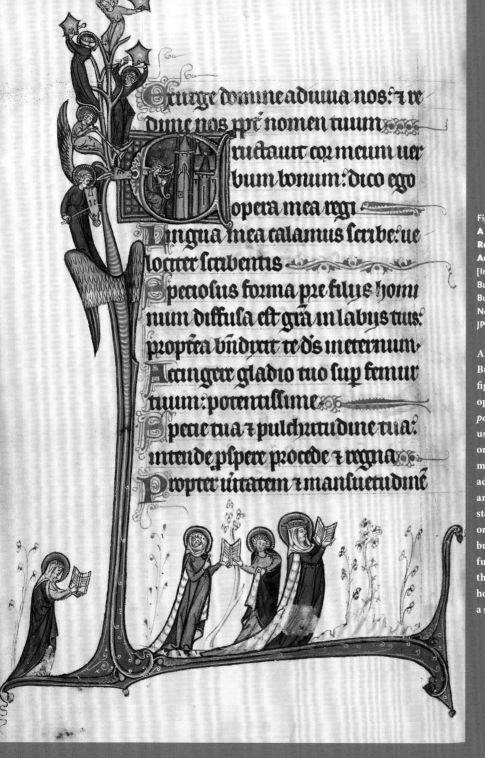

Fig. 13 ◁
A Saintly Queen and Attendants Reading from Books (*bas-de-page*); **Angel Musicians** (upper left), [Initial *E*: David Playing the Harp]
Bute Master
Bute Psalter
Northeastern France, ca. 1270–80
JPGM, Ms. 46, fol. 61v

Although the artist known as the Bute Master painted the marginal figures of a queen and her court in opaque pigments in this *bas-de-page*—the same pigments as those used for the historiated initial and orchestra of angels above—the minimal landscape details were added in simple washes of blue, red, and brown ink. These sprouting stems and the light mound of earth only tentatively indicate a setting, but they herald a tradition of more fully rendered landscapes unique to the *bas-de-page*, in which the lower horizontal line of the border provides a solid platform for the action.

Fig. 14 ▷
Two Knights Begging a Pardon from a Nobleman
[Christ Blessing]
Master of the Berlin Crucifixion or circle
(miniature) and Master of Jean Chevrot or circle
(*bas-de-page*)
Leaf from the Turin-Milan Hours
Bruges, ca. 1440–45
JPGM, Ms. 67, verso

In the fifteenth century, illuminators still often took advantage of the stage-like space of the *bas-de-page* to expand the overall program of illustrations, especially in books made for the wealthiest patrons. The iconic image of Christ in this miniature is complemented in the *bas-de-page* by a scene that relates the adjacent text to contemporary life. The text is a prayer to Christ to help the book's owner forgive his persecutors, while in the tiny marginal painting, a nobleman pardons two kneeling men, who presumably have committed some offense against him. The figures are dressed in the most up-to-date fashions, and the action plays out in the foreground of an expansive, naturalistic landscape.

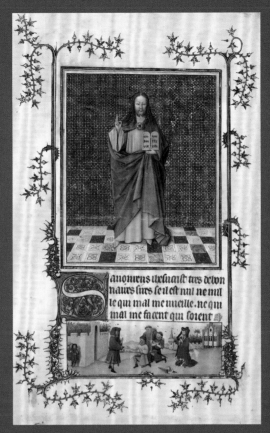

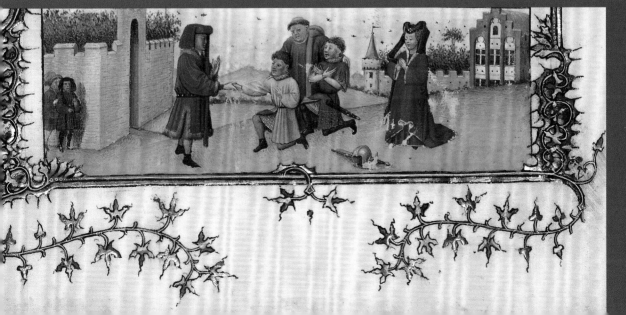

qui te expectat no cōfūdet

Missal
Master of the Brussels Initials
Bologna, between 1389 and 1404
JPGM, Ms. 34

Fig. 15 ◁ ▷
Figures, Animals, and Hybrids
[Christ in Majesty]
fol. 7

On this page, the Master of the Brussels Initials framed a radiant image of Christ and the opening words of the text with one of his characteristic inhabited borders. Among the twisting and turning acanthus leaves, you will find an eagle, other birds, human faces, a hooded lion of sorts, children climbing and playing, figures making music, men in combat, a pearl diver, and a macabre horned devil lurking in the shadows of one of the initials. In the initial *A* itself (in the left-hand column of the text), a man, possibly Abraham, delivers a soul (perhaps that of the man who owned the book) in the form of a small naked being to Christ, echoing the words sung by the choir at the beginning of the text: "To you, O Lord, I lift up my soul"—away, that is, from the worldly mayhem seen in the margins.

Worth considering a little more closely is the pearl diver—the naked figure with a conical weight strapped to his (or her?) back (in the lower left corner of detail at left). The pearl was one of many medieval symbols for the Virgin Mary, who is shown in the main image presenting the owner of the manuscript to Christ; a pearl diver is a less common subject, however, and might have been a personal symbol for this artist, as it appears in other borders that he painted.

Who's Living in the Margins? Inhabited Borders

The unusually expressive borders of this manuscript, with their billowing leaves inhabited by men, beasts, and hybrid creatures, deserve special attention because they represent a bridge between the whimsical arrangements of earlier margins and the more carefully staged and animated borders of fifteenth-century illuminated manuscripts. The anonymous Master of the Brussels Initials who illuminated this manuscript was named for the decorated letters he painted in a book of hours, now in Brussels, for Jean, Duke of Berry, brother to King Charles V of France and a great bibliophile (lover of books). In the manuscript here, made for Cardinal Cosimo de'Migliorati (later Pope Innocent VII) before 1404, the Master of the Brussels Initials executed all the illumination, including the borders.

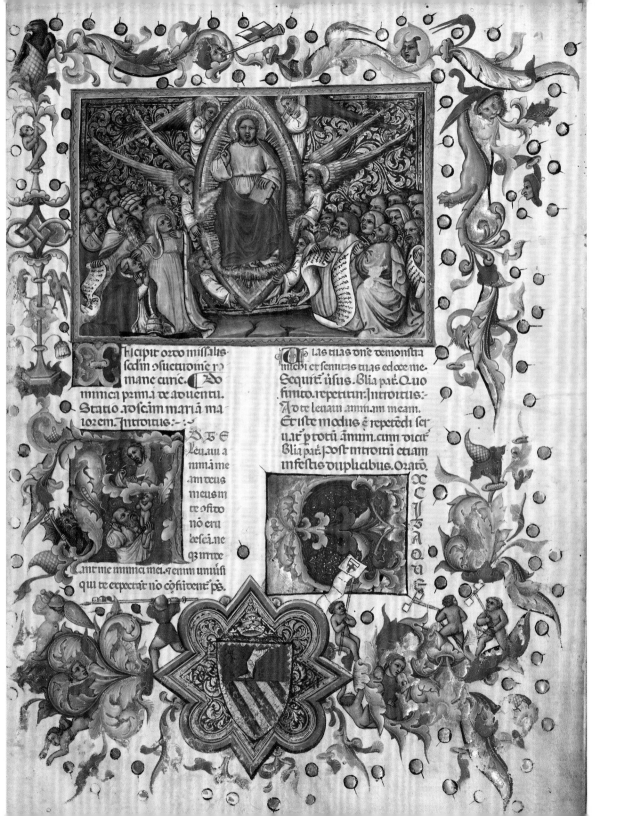

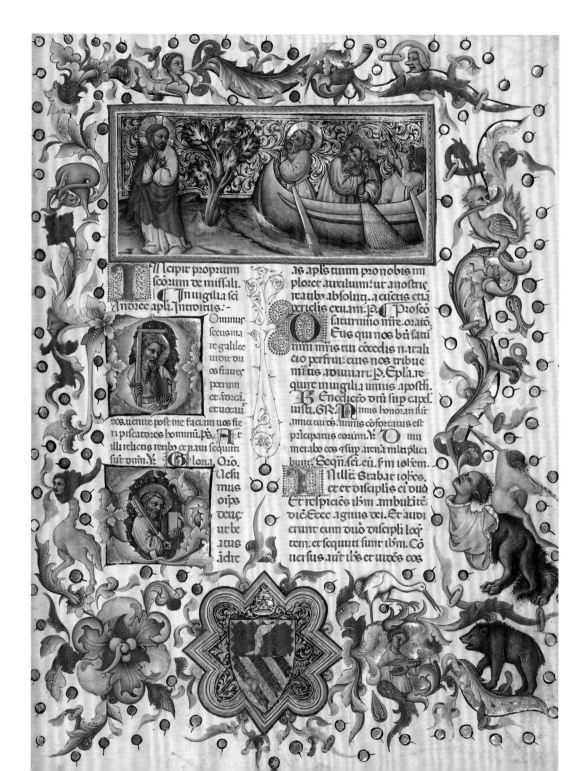

Fig. 16 ◁
Figures, Animals, and Hybrids
[The Calling of Saints Peter and Andrew]
fol. 172a

The individual elements of this border are familiar from medieval marginalia. The hybrids, naturalistic animals, lute player, and the chainlike construction—one creature "spewing" or "sprouting" an acanthus vine that morphs into the platform or tail of another—can be seen in many earlier medieval borders (fig. 2). But there is an unprecedented liveliness here, in the actions of the figures, in the fullness of the design, and in the scintillating effect of the golden balls, turning and floating like bubbles in the gentlest puff of air.

Fig. 17 ▷
Comic Heads
[The Resurrection]
fol. 135v

Even within the more minimal leafy forms of this partial border, the comical heads—of two storklike birds, a caricatured man, a woman with a white head-covering, and a blue dragon—stand out as animated counterpoints to the sleeping soldiers in the depiction of Christ's Resurrection, who are seen in the main image and the historiated initial.

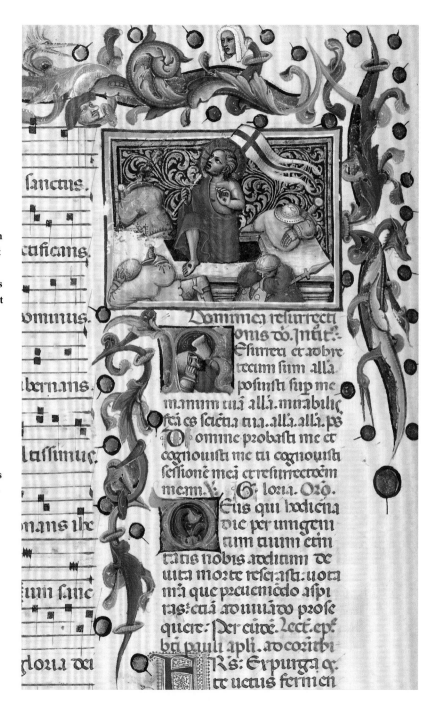

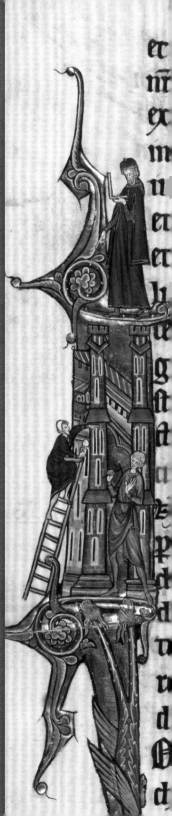

RENAISSANCE FRAMES

Marginalia did not disappear with the beginning of the Renaissance. Fifteenth- and sixteenth-century illuminators inherited a rich legacy of marginal motifs from their medieval predecessors, but they usually integrated these motifs into the more formal arrangement of a densely designed foliate border (figs. 20 and 22), or into a unified world characterized by naturalistic landscapes (fig. 19). This formalization of the manuscript page signaled the illuminators' growing awareness and adaptation of popular trends in late medieval and early Renaissance panel painting, where elaborately carved wooden frames, sometimes with their own marginal images and words, were popular. Although the era of marginalia has generally been considered to end with the closing of the Middle Ages, in this selection of pages, and in several examples from the following two chapters, we see how the descendants of the images in the margins of medieval manuscripts, despite the visual formality of their new contexts, assumed similarly playful, symbolic, and otherwise meaningful roles in the Renaissance.

Fig. 18 ▷
Initial *I*: The Rebuilding of the Temple
Marquette Bible
Probably Lille, ca. 1270
JPGM, Ms. Ludwig I 8, vol. III, fol. 256v

Fig. 19 ▷▷
The Building of the Tower of Babel
[Elijah Begging for Fire from Heaven]
Master of James IV of Scotland
Spinola Hours
Bruges and Ghent, ca. 1510–20
JPGM, Ms. Ludwig IX 18, fol. 32

Painted 250 years apart, the scenes of construction in the Marquette Bible and the Spinola Hours make a striking comparison. Each illuminator has depicted the making of a biblical monument according to the artistic and building conventions of his own time. In the shared fascination with the same everyday subject, however, they demonstrate how the margins persisted as a favored location for visual play from the later Middle Ages to well into the Renaissance.

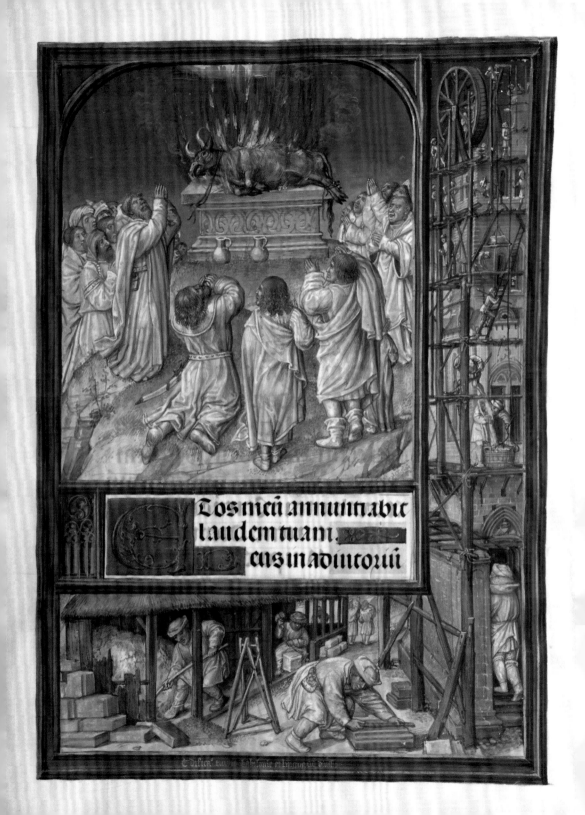

os meū annūtiabit
laudem tuam.
eus in adiutorū

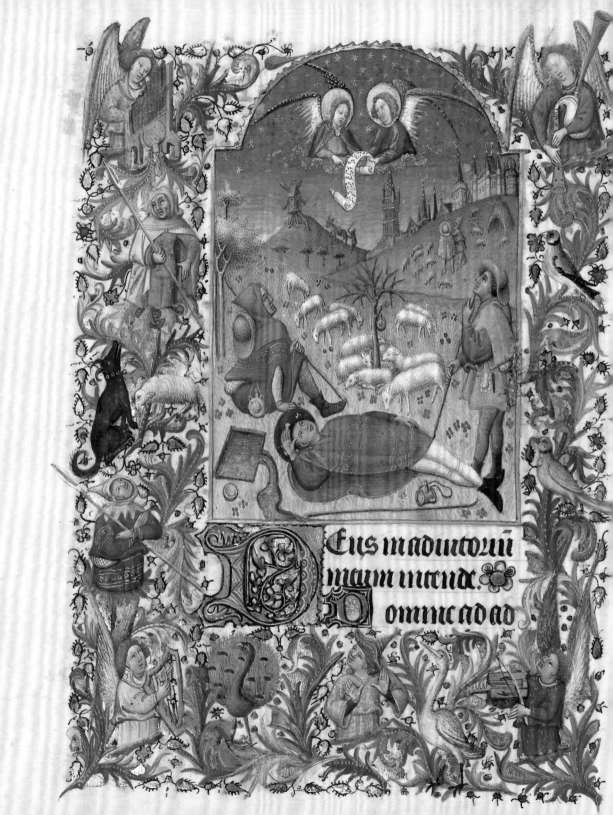

Eus madiutoriu
meum intende.
Domica ad ad

Fig. 20 ◁
Shepherds, Angel Musicians, and Birds
[The Annunciation to the Shepherds]
Spitz Master
Book of hours
Paris, ca. 1420
JPGM, Ms. 57, fol. 89v

Fig. 21 ▽
A Pelican, a Dog, and Seahorses
[Saint Catherine of Alexandria]
Taddeo Crivelli
Gualenghi-d'Este Hours
Ferrara, ca. 1469
JPGM, Ms. Ludwig IX 13, fol. 187v

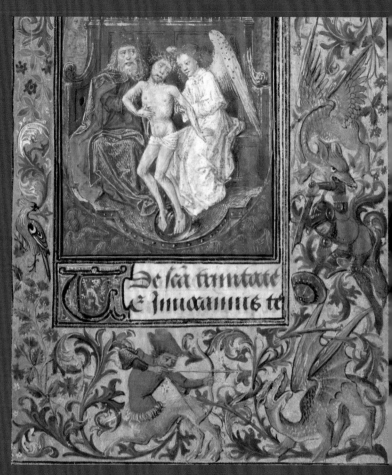

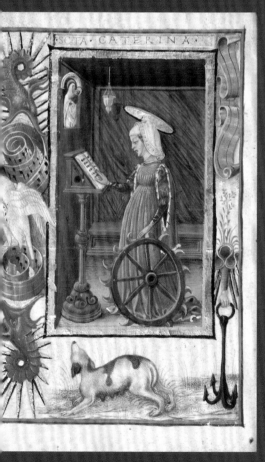

Fig. 22 △
A Hybrid Creature and a Knight Battling Dragons
[The Trinity]
Lieven van Lathem
Prayer Book of Charles the Bold
Ghent and Antwerp, 1469
JPGM, Ms. 37, fol. 14

THE W ORLD OF THE MARGINS

The margins of medieval and Renaissance manuscripts are populated by a vibrant mix of humans, animals, and composite creatures (hybrids), engaged in activities that range from the sweetly mundane (figs. 24 and 25) to the amusingly mocking (fig. 23). Illuminators drew their ideas from both visual and literary sources, and while there are overtly religious images among them (from scripture, fig. 67, and the lives of the saints, fig. 61), most marginalia fall into one or more of the following categories: everyday human life, the animal kingdom writ large (with realistic, fantastic, and comical characters), and instances of the natural order turned upside-down. There are plenty of marginalia as well that are just "hanging out"— single or paired figures that are not part of an identifiable action or interaction but still add to the visual and symbolic interest of a given page, through suggestive arrangements, physical comedy, or sheer artistic bravado (fig. 48).

Fig. 23 ▷
A Monkey Physician
(*bas-de-page*) **and a**
Carnival Character
(middle right)
[Initial *D*: The Adoration
of the Magi]
Ruskin Hours
Northeastern France,
ca. 1300
JPGM, Ms. Ludwig IX 3,
fol. 89

t clamor meus ad te ueniat.

Benedicamus domino. Deo gras.

Eus in noune.

in adiutorium

meum intende

domine ad ad

iuuandum me

festina Gloria patri Sicut

erat ymue Veni crator sps

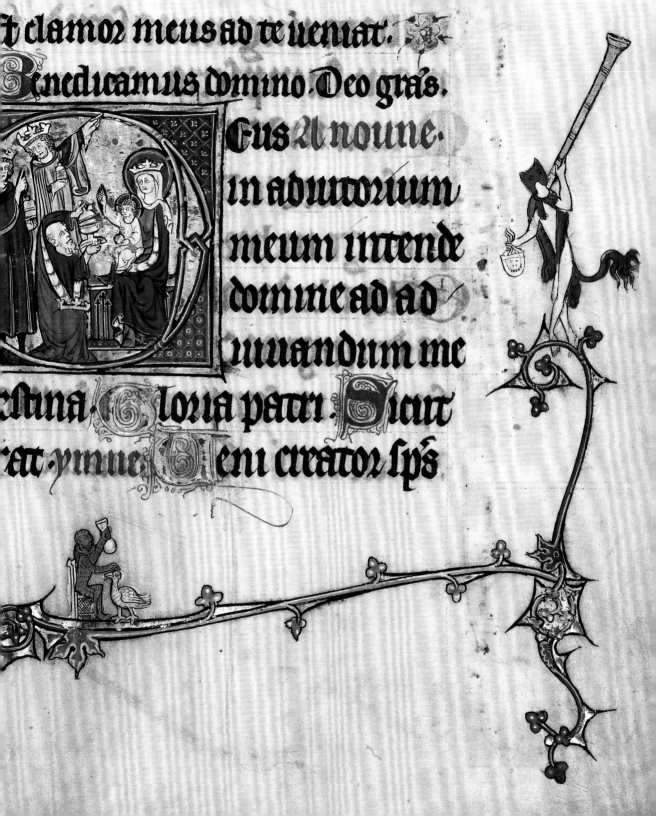

Illuminators found a ready source for marginalia in the direct observation of the world around them. Frequently depicted were the commonplace tasks of the kitchen, field, and workplace, and the pleasures of life beyond such labors, especially games and music. Many of the everyday scenes also had a basis in artistic tradition, in particular the cycle of seasonal labors and activities that had illustrated liturgical calendars (lists of important church celebrations) from as early as the eleventh century. These scenes, which were specifically associated with different times of the year, were themselves often drawn in the margins and followed fairly predictably the annual agrarian cycle of plowing, sowing, and harvesting (fig. 26), interspersed with the more leisurely pursuits of the nobility, such as feasting, riding, and hawking (fig. 28). Later medieval illuminators expanded upon this tradition by reworking individual calendar motifs, especially those concerned with agriculture (fig. 25) and hunting (fig. 27).

Fig. 24 ▷
A Woman Churning Butter
Antiphonal
Northeastern France or Flanders,
ca. 1260–70
JPGM, Ms. 44/Ludwig VI 5, p. 135

Fig. 25 ▷▷
A Man Winnowing
[Initial *D*: A Man Threshing Wheat
with a Flail]
Bute Master
Bute Psalter
Northeastern France, ca. 1270–80
JPGM, Ms. 46, fol. 129v

Quod exprobrauerunt inimici tui
domine: quod exprobrauerunt com
mutationem xpristi tui

Bndictus dns in eternum: fiat fiat
omine refugium. tus es no
bis: a gnatoe in gnatcem

Priusquam montes fierent aut
formarentur terre et orbis: a seculo
t in seculum tu es ds.

Neauertas hominem in humili
tatem: t dixisti connertimini filu
hominum

Qm mille anni ante oculos tuos:
tamq dies hesterna que weteriit

Et custodia in nocte: que pro ni

Fig. 26 △
Plowing (January)
Julius Calendar and Hymnal
England, early eleventh century
BL, Cotton Julius Ms. A.VI, fol. 3

Fig. 28 ▷
A Man Hawking
Ruskin Hours
Northeastern France, ca. 1300
JPGM, Ms. Ludwig IX 3, fol. 6v

Fig. 27 ▷
A Stag Hunt
Ruskin Hours
Northeastern France, ca. 1300
JPGM, Ms. Ludwig IX 3, fol. 76

Hunting was the exclusive privilege
of the aristocracy in the Middle Ages,
and although this stag hunt might
have triggered some nostalgia for the
manuscript's owner, like so much else in
the margins, it also has an established
symbolic meaning. The stag is a symbol
for Christ, and in the Middle Ages its
escape from the hunter was equated with
the moral vigilance of the good Christian,
who, by leading a devout life, eludes the
snares of the devil.

imple ſuperna gratia que tu
creaſti pectora ·

Mai a· xxxi· iour· li lune· xxx·
Saint felip ꞇ ·S· Jakeme·

Le sainte Crois·　　　　D

Saint Johan l'euangeliste

Saint piere ueske en ax

Saint machare· Etacis inau

Sainc gordian·

Saint seruas·

Fig. 29 ▽
Men Swimming
Queen Mary Psalter
England, ca. 1310–20
BL, Royal Ms. 2 B.VII, fol. 170

In this unusual depiction of swimming,
one man treads water while the other
appears to be performing some version of
the breaststroke—a prosaic visualization
of the phrase in the last two lines of text
on the page: "Out of the depths of the
waters" (*de profundis aquarum*).

Fig. 30 ▷
A Blacksmith Making a Horseshoe
Book of hours
England, ca. 1320–30
BL, Harley Ms. 6563, fol. 68v

So central a role did the blacksmith play in
medieval life that reference to the trade in
marginalia is not particularly surprising.
In this example, the illuminator depicted
with equal interest the action of forging
a horseshoe and the setting of the smithy,
down to the flames dancing within the
square opening to the furnace at right.

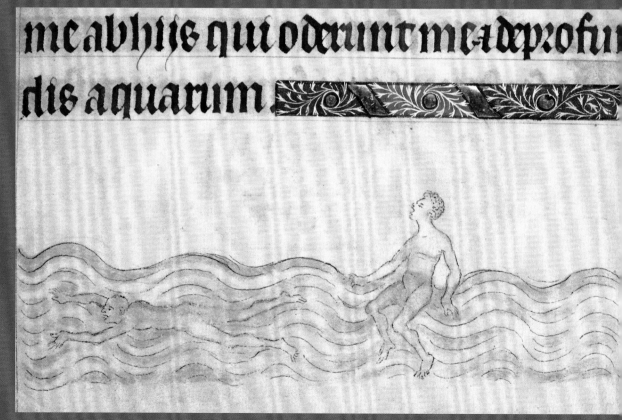

Who's Playing in the Margins? Marginal Games

Children's games represent one of the larger categories of everyday subjects found in the margins of illuminated manuscripts. Ranging from the physically brutal sports of "hot cockles" (fig. 32) to the tactical challenge of board games (fig. 35), the scenes of marginal play have a striking familiarity for us. This manuscript was illuminated in the 1330s for the Count Bishop of Châlons-sur-Marne, a powerful French priest and member of the royal court. The depictions of children's games in its margins are universally appealing, largely because of the lively gestures of the participants. The youths grab, point, reach, hold, and exclaim, conveying the true-to-life and timeless emotions of the playground. What more they meant to the patron is hard to say, but perhaps in the fractious drama of play he found a metaphor for contemporary French royal politics.

Breviary
Mahiet?
Paris, ca. 1320-25
JPGM, Ms. Ludwig IX 2

Fig. 32 ▷
Children Playing Hot Cockles
[Initial *P*: A Funeral Service]
fol. 99

The game of "hot cockles" is a buffeting game in which the person who is "it" hides his face in another player's lap, while a third player bumps, prods, or simply hits him. If the central player can identify the assailant, he is freed; if not, the game continues. Here the lone girl, holding the head of the designated boy, wears an expression of concern, perhaps at the heaviness of the blows.

Fig. 31 ▽
A Game of Balance and a Monkey Examining a Urine Jar
fol. 357

Tests of balance are quite common among the childhood games found in marginalia. Here the middle figure pushes his raised foot against the leg of a seated opponent and does his best to stay upright.

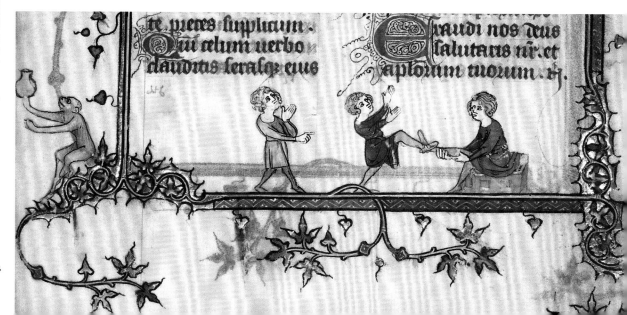

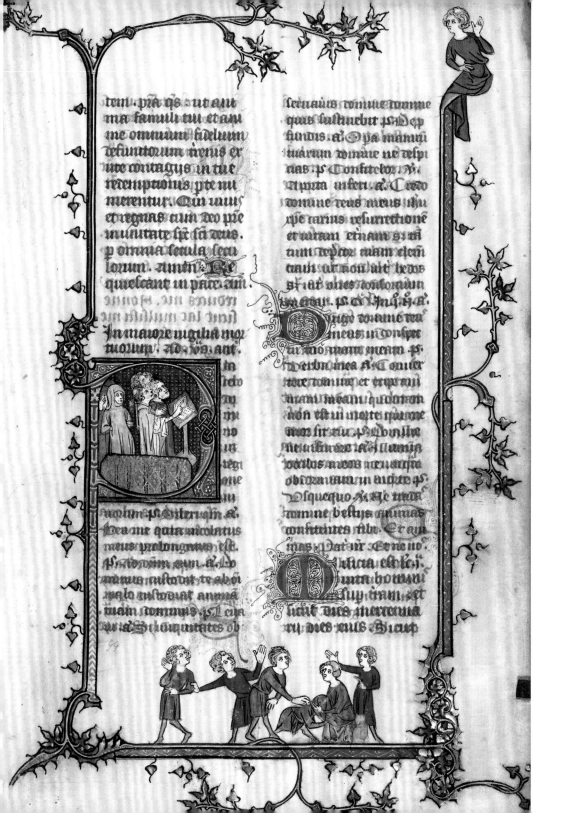

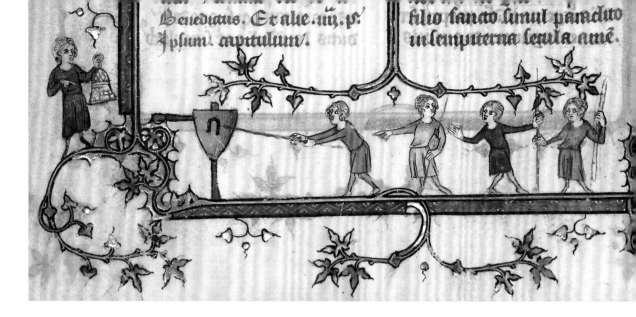

Fig. 33 △
**Boys Tilting at a Quintain and a Youth
with a Bird Cage (?)**
fol. 107v

In the page shown above, a group takes
turns striking at a quintain, a jousting
target with a shield and wooden arm
mounted to a post. The gestures of the
three to the right suggest a dispute over
who goes next, a squabble all too familiar
from playgrounds of any era. Like the
mock combat with sword and buckler
on another page (fig. 34), tilting at the
quintain was just one of many medieval
games that introduced young men to the
military arts.

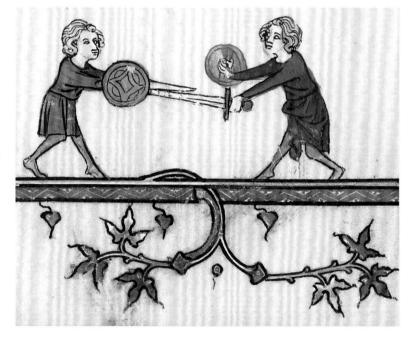

Fig. 34 △
Boys Dueling with Swords and Bucklers
fol. 311v

Fig. 35 ▷
Boys Playing a Board Game
fol. 142

Fig. 36 ▽
Boys Playing Kayles and a Monkey with a Mirror
fol. 318v

Of the games that required special equipment, chess and checkers figure prominently in the margins of this manuscript, as do various games that were forerunners of the modern sport of bowling. It is unclear whether the artist intended this sketchy square at right to represent a checkerboard or some other kind of game board, but in the page below the figures are clearly playing a game called kayles or club-kayles, in which the pins are knocked down by the toss of a stick or club.

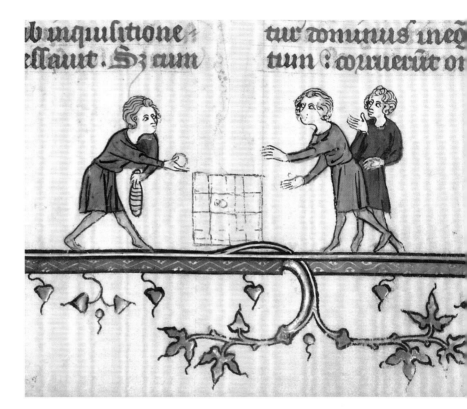

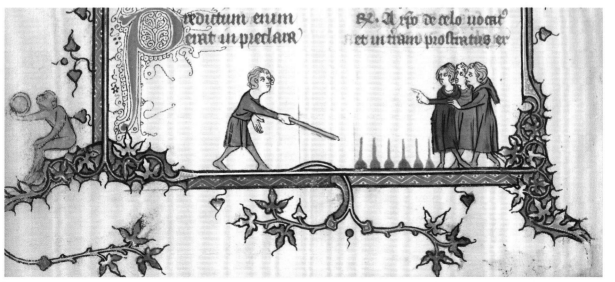

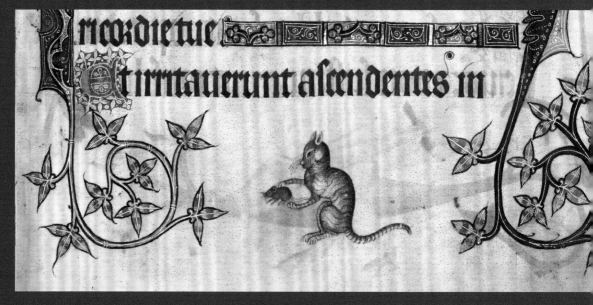

THE ANIMAL KINGDOM

In marginalia we find animals of all kinds, whose depictions draw upon direct observation (especially with birds, see figs. 41, 42, and 43), popular lore, and epic tales and fables, as well as the moralizing "book of beasts," known as the bestiary. Like the treatment of the animals in these varied sources, their depiction in the margins ranges from naturalistic rendering to clichéd motif to popular parody. Of the real animals, monkeys, dogs, rabbits, and birds are the most prevalent, but cats and mice, lions, bears, horses, and even snails and insects appear. The fox is a special case, because it appears in the margins almost exclusively as the wily character Renard (fig. 40). Mythical beasts, which in bestiaries were not distinguished from the real animals, also play a sizable role. Whether real or imaginary, the animals are often presented in antagonistic pairs—cat with mouse, hound with hare, fox with fowl —suggesting a symbolic parallel with the theme of good versus evil in so many of the prayers in the same manuscripts.

Fig. 37 △
A Cat Playing with a Mouse
Luttrell Psalter
England, ca. 1330–45
BL, Add. Ms. 42130, fol. 190

This timeless image of a cat clutching a mouse in its paws owes as much to tradition as to observation. Perhaps the grey stripes were inspired by the artist's own feline, but the cat's actions correspond to both the conventional illustration type and the brief written description of the cat found in most medieval bestiaries, where it is celebrated for its skill in killing mice and for its renowned night vision.

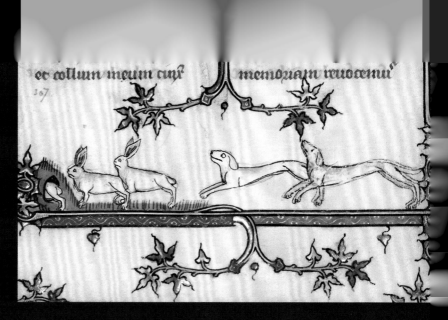

Fig. 38 ▷

Hounds Chasing Rabbits into Holes
Mahiet?
Breviary
Paris, ca. 1320-25
Ms. Ludwig IX 2, fol. 308

Related to the popular theme of hunting, the motif of the hound chasing rabbits or hares ranks among the most common in marginalia. It can be interpreted as a metaphor for reading, with the hounds as readers chasing the words across the page. In line with medieval beliefs, the hound could also be viewed as man's protector, chasing away evil, for which the rabbit was a common and favored metaphor.

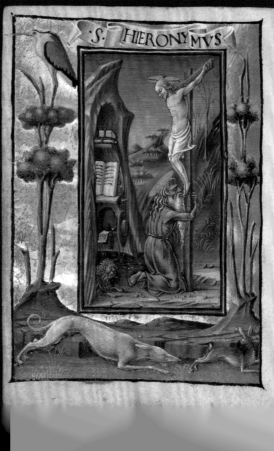

Fig. 39 ▷

A Hound Chasing a Hare
[Saint Jerome in the Desert]
Taddeo Crivelli
Gualenghi-d'Este Hours
Ferrara, ca. 1469
PGM, Ms. Ludwig IX 13, fol. 174v

In the hands of the great Renaissance painter Taddeo Crivelli, the hound chasing the hare in this border achieves a dramatic intensity equal to that of the penitent Saint Jerome, clinging to the large sculpted crucifix in the center of the image. No less meaningful is the great gray heron in the upper left corner. According to the bestiary, the heron flew above the clouds to avoid storms. Because of this quality, it could signify the "souls of the elect," who, like Saint Jerome, "fear the disorder of this world, lest they be caught . . . in the storms of persecution stirred up by the Devil."

Fig. 40 ▽
**Renard Preaching to Two Hens and
a Goose**
Book of hours
Southern Netherlands (Liège), ca. 1310–20
BL, Stowe Ms. 17, fol. 84

So popular were the stories of this trickster and medieval anti-hero that his name, Renard, became the French word for fox in everyday usage by the thirteenth century. In marginalia, his exploits are limited to a few scenes that emphasize how cunningly he could satisfy his voracious hunger. In this private devotional book, he assumes his most common disguise, as a preacher, to secure the misplaced trust of two roosters and a goose. Irreverent? Yes. Unacceptable? Apparently not. In medieval animal epics, of which the tales of Renard are just the best known, parodies of preachers, nuns, knights, and gullible humans of all classes abound.

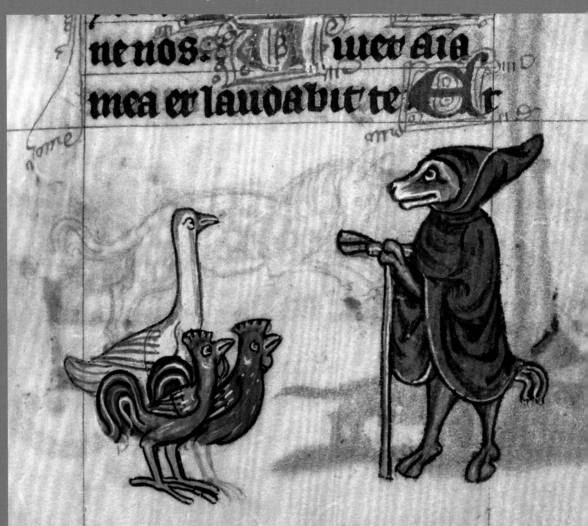

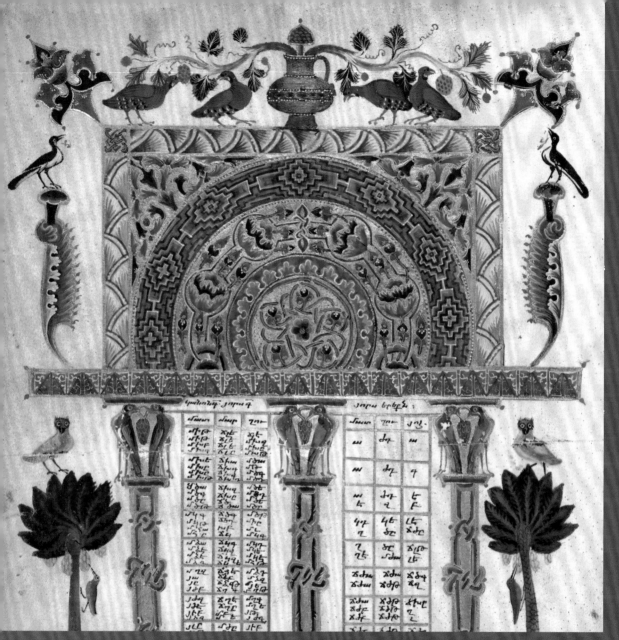

Fig. 41 △
Canon Table Page with Partridges, Magpies, and Other Birds
T'oros Roslin
Canon Table from a Gospel Book
Hromklay (Armenia), 1256
PGM, Ms. 59, fol. 3v

Because of their vast natural differences, birds are among the most visually varied class of animals to be found in the margins. The care taken to depict the specifics of diverse species suggests that there were some budding ornithologists among medieval illuminators. In this example, the gray belly, red legs, striped wing tips, and black-and-white coloring around eye and beak, identify the plump birds at the top of the page as rock partridges, which are native, as was the artist, to Armenia.

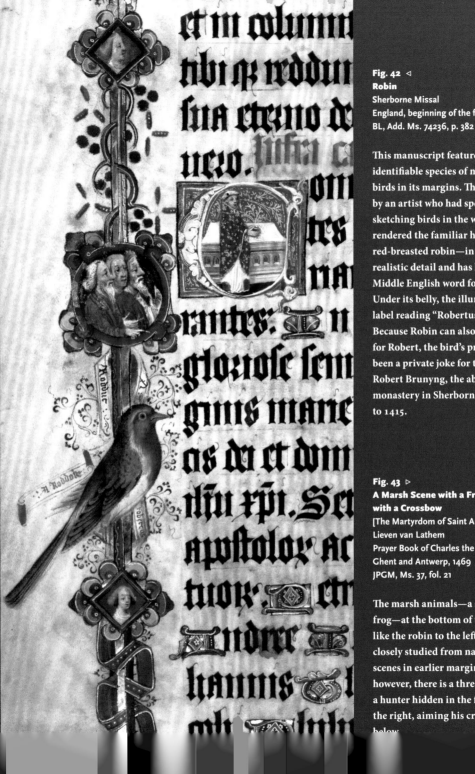

Fig. 42 ◁
Robin
Sherborne Missal
England, beginning of the fifteenth century
BL, Add. Ms. 74236, p. 382

This manuscript features over forty identifiable species of naturalistically rendered birds in its margins. They were likely painted by an artist who had spent considerable time sketching birds in the wild. Here the artist has rendered the familiar harbinger of spring—the red-breasted robin—in especially fine and realistic detail and has labeled it twice with the Middle English word for Robin, "Roddock." Under its belly, the illuminator also tucked a label reading "Robertus," Latin for Robert. Because Robin can also serve as a nickname for Robert, the bird's presence might have been a private joke for the manuscript's owner, Robert Brunyng, the abbot of the Benedictine monastery in Sherborne, England, from 1385 to 1415.

Fig. 43 ▷
A Marsh Scene with a Frog and a Hunter with a Crossbow
[The Martyrdom of Saint Andrew]
Lieven van Lathem
Prayer Book of Charles the Bold
Ghent and Antwerp, 1469
JPGM, Ms. 37, fol. 21

The marsh animals—a stork, a spoonbill, and a frog—at the bottom of this border are drawn, like the robin to the left, as if they had been closely studied from nature. As in other animal scenes in earlier margins (see figs. 12 and 27), however, there is a threat here, in the form of a hunter hidden in the foliage of the border to the right, aiming his crossbow at the animals below.

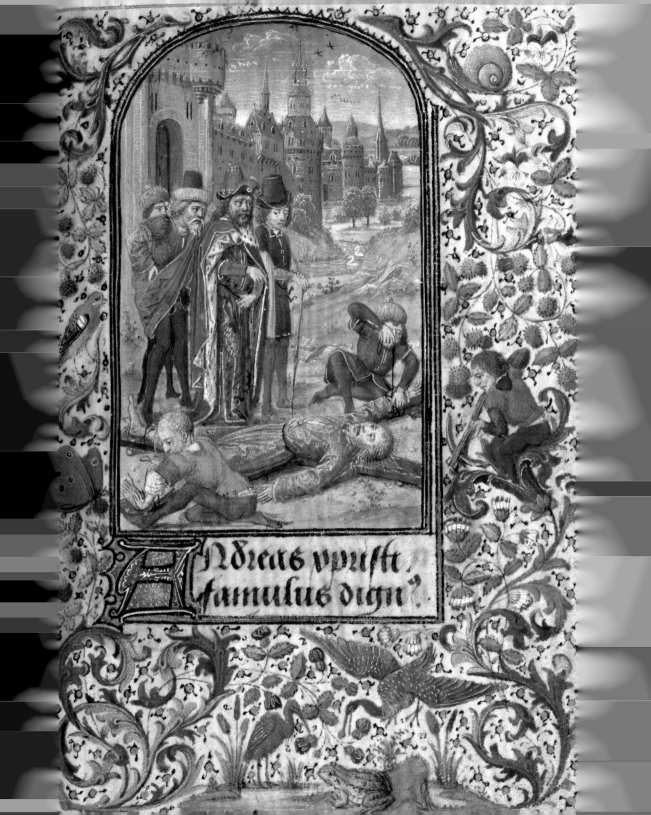

Fig. 44 ◁
A Unicorn and a Griffin
[Initial *D*: The Flight into Egypt]
Ruskin Hours
Northeastern France, ca. 1300
JPGM, Ms. Ludwig IX 3, fol. 98v

Of the fabulous beasts that appear frequently in medieval stories, the unicorn and the griffin are among the best known to modern readers. Here the two square off at the bottom of a prayer to the Virgin Mary in a French devotional manuscript. Like the hound and the hare (figs. 38 and 39), this is an adversarial pairing, with the griffin, reputedly hostile to both man and horse, pitted against the stately unicorn, which was favorably viewed in the Middle Ages as a symbol of Christ.

Fig. 45 ▷
A Griffin
Northumberland Bestiary
England, ca. 1250–60
JPGM, Ms. 100, fol. 26

The griffin seen in the margins of the image at left (fig. 44) corresponds closely to the bestiary description and its usual illustration: "at once feathered and four footed" (*see* right).

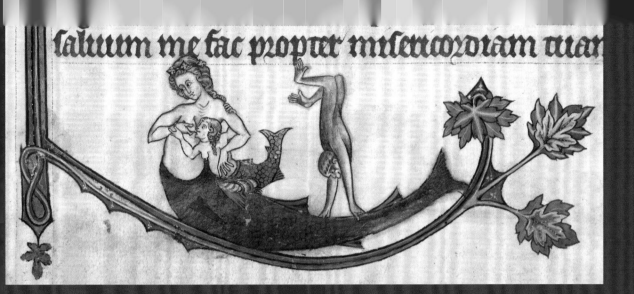

saltum me fac propter misericordiam tuam

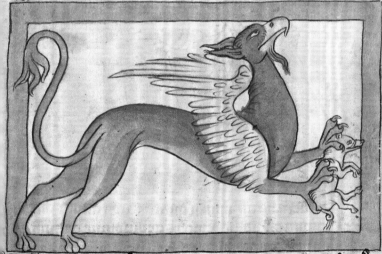

unū non admutūe ferum. Oculos habentes: minū penetrantes.

Rifes uocatur qd sit animal pennatū τ quadrupes hj genī serarum inhy ploreis naseii ieris ul̄ miotibz oim̄ pte corpris tile leonī Alis τ facie aquil' simile equis uehemter inf estum nam τ homines uisos discerpit.

Fig. 46 △
A Monkey Doing a Handstand on the Back of a Mermaid Nursing Her Young
Alphonso Psalter
England, before 1284
BL, Add. Ms. 24686, fol. 13

In the bestiary, the sailors who succumbed to the siren's song were equated with men who "lose the vigor of their minds by listening to comedies, tragedies and various musical melodies." Mermaids are not described in the bestiary, but they were commonly associated with sirens in the Middle Ages and were ascribed many of the same attributes. As sweet as this mermaid nursing her child might look to us, she, too, could serve as a warning against taking too much delight in the entertainment in the margins!

But what shall we say when nowadays so many people appear to be human outwardly but inside are worse than wild animals? For all they seem to be like those images called babewynes . . . which painters depict on walls.

—FASCICULUS MORUM, Fourteenth Century

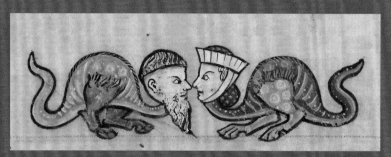

The most common species to appear in medieval margins has no established pedigree, either from mythology or literary sources, but is made up from parts of different beings, animal and human, as well as plants and things of uncertain origin. "Hybrid" is one very general name given to these creatures. Some modern scholars have called them "nondescripts," a term borrowed from the science of natural history for forms not easily named. In a fourteenth-century English sermon, they were referred to as *babewynes* and equated with hypocrites (*see* quote above). Whatever you choose to call them, you will find such composite creatures throughout later medieval art, sculpted in stone and wood, and painted on walls and glass windows. In the margins of manuscripts they take on their most animated forms. They are by and large comical characters who perform the same tasks as humans in marginalia—making music (fig. 50), hunting, fighting, eating, and drinking. But unlike their fully human counterparts, they can convey different meanings while delighting the viewer, who in many cases is busy just trying to figure out how they are pieced together.

Fig. 47 ◁
Hybrid Couple Rubbing Noses
Antiphonal
Northeastern France or Flanders, ca. 1260–70
JPGM, Ms. Ludwig VI 5, leaf 23

In this pair of hybrids, the heads of a man and woman are attached to spotted dragon-like bodies. Although the rubbing of noses suggests an amorous coupling, the meaning of the hybrids is by no means certain. The serpent bodies could be read as symbols of the sin of lust, especially given that the man might be identified as a monk by his haircut, and hence would be violating his vow of celibacy. But there is plenty of humor here, too, in the idea that perhaps it was their immoral behavior that led to their transformation in the first place.

Fig. 48 ▷
Hybrids
Luttrell Psalter
England, ca. 1330–45
BL, Add. Ms. 42130, fol. 182v

The bizarre accumulation of parts that make up the three hybrids on this page, and their visually dominating presence, led one modern scholar to remark that they could not have been the product of a sane mind. In fact, they are just an extreme manifestation of this popular late medieval figure type.

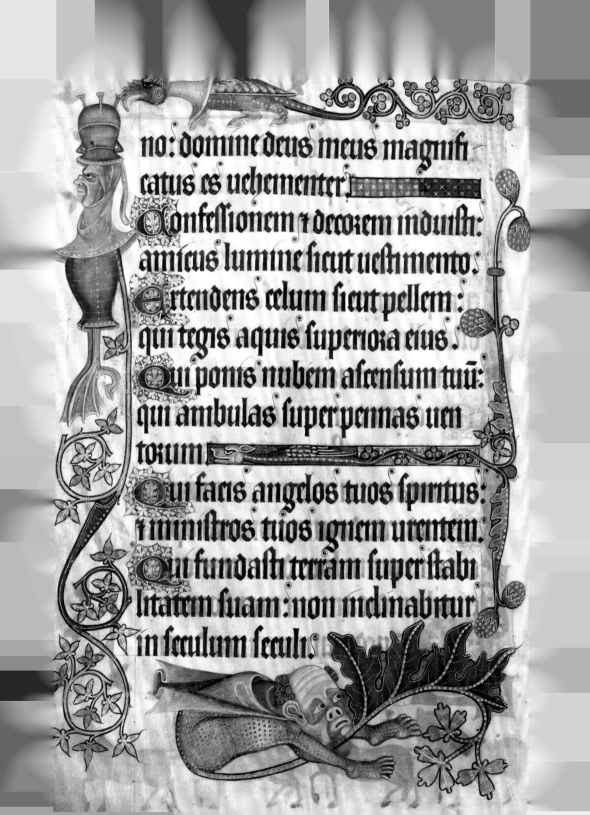

no: domine deus meus magnifi
catus es uehementer.

Confessionem ⁊ decorem induisti:
amictus lumine sicut uestimento.

Extendens celum sicut pellem:
qui tegis aquis superiora eius.

Qui ponis nubem ascensum tuũ:
qui ambulas super pennas uen
torum

Qui facis angelos tuos spiritus:
⁊ ministros tuos ignem urentem.

Qui fundasti terram super stabi
litatem suam: non inclinabitur
in seculum seculi.

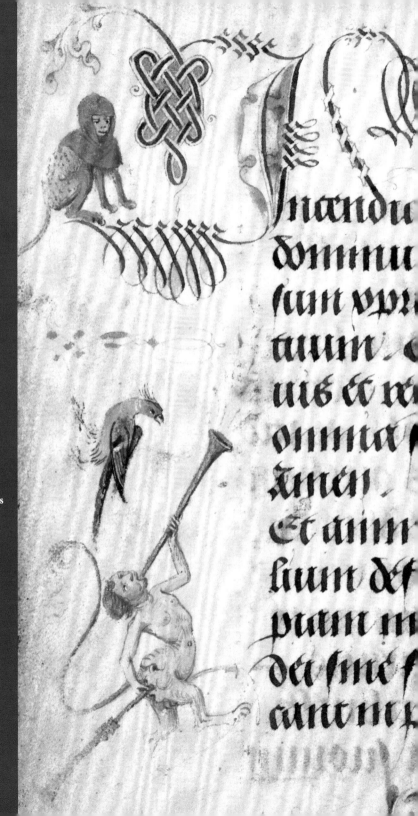

Fig. 49 ▷
**A Monkey, a Bird, and a Hybrid
Blowing Two Horns**
Lieven van Lathem
Prayer Book of Charles the Bold
Ghent and Antwerp, 1469
JPGM, Ms. 37, fol. 32v

Some marginalia need no explana-
tion. Nevertheless, it might be of
interest to know that rude and lewd
subjects were prevalent in the margins
of both medieval and Renaissance
manuscripts. Hybrids were especially
employed in scenes that focused on
bodily functions, which are repre-
sented with surprising frequency in
the margins.

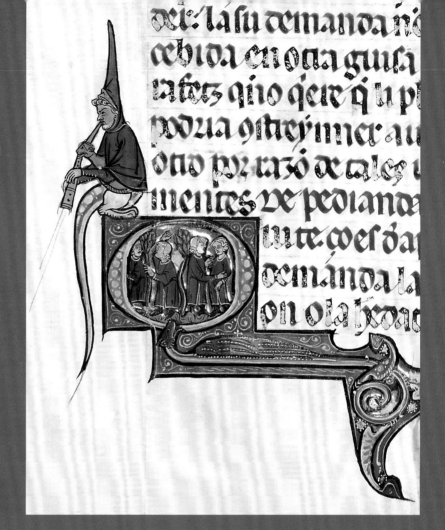

Figs. 52 ◁ ▽
Hybrids and Medallions
[Initial *D*: Saint John the Baptist]
Matteo da Milano
Missal
Rome, ca. 1520
JPGM, Ms. 87, fol. 4

There is a formal quality to this Renaissance border with its orderly arrangement of three-dimensional flowers and gems, to which the hybrids at the bottom add a degree of what was called in the sixteenth century the "grotesque." The combination of disparate parts makes these figures not unlike what you see in earlier medieval hybrids, but their vibrant colors, which reflect the particular shades of the decorative world immediately surrounding them, are something new.

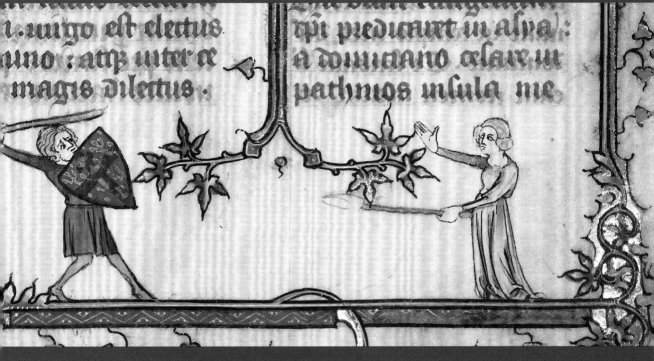

i. uirgo est electus
uno : atqz inter ce
magis Dilectus :

rpi predicauit in afya :
a domitiano celare in
pathmos infula me

THE WORLD UPSIDE-DOWN

Humor plays a large part in marginalia, in the depiction of individual figures, such as the hybrids, and in scenes that poke fun at the professions of humans by replacing them with animals. Another bountiful brand of marginal humor can be found in encounters that turn the natural behavior—of both humans and animals—upside-down. Unlike the Renard scenes (fig. 40) or the monkey doctor (fig. 23), however, these topsy-turvy episodes rely much less on literary or other visual traditions. Some scenes, such as mock jousts (fig. 54), belong to the world of medieval carnival entertainment. Others are set themes, such as the battle of the sexes and the hunter turned prey, to which individual artists added their own witty insights.

Fig. 53 △
A Man Defending Himself Against a Woman Wielding a Distaff
Mahiet?
Breviary
Paris, ca. 1320–25
JPGM, Ms. Ludwig IX 2, fol. 139

The man's furrowed brows would suggest that he is facing serious harm from a woman threatening him with a distaff, which is really just a domestic tool used for holding unspun wool or flax.

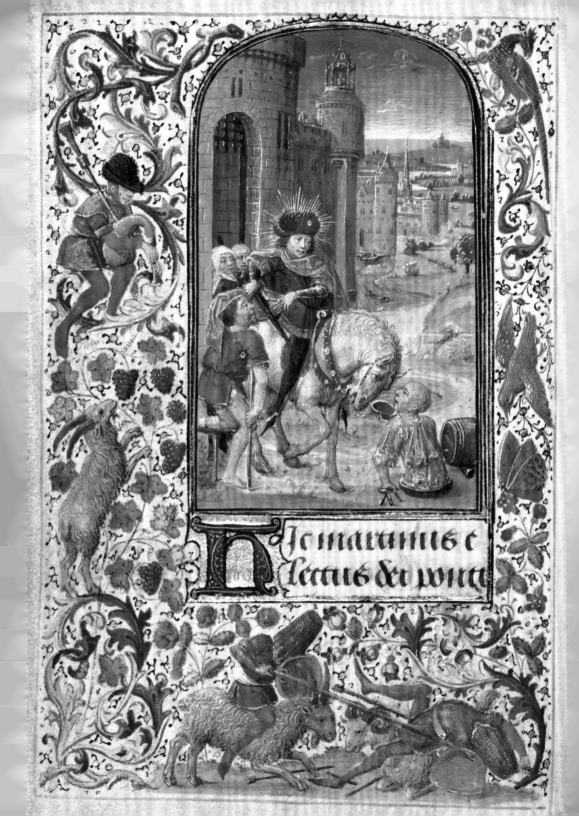

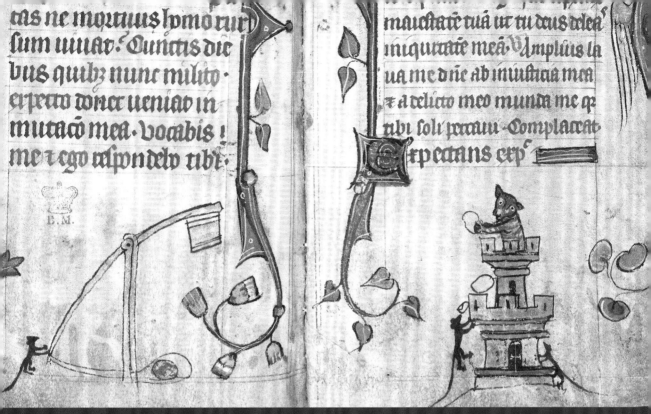

as ne mortuus homo rurium uiuar. Cunctis diebus quibz nunc milito expecto doner ueniar in mutaco mea. Vocabis me z ego respondebo tibi

maiestate tuā ut tu deus delea iniquitate mea. Amplius laua me dne ab iniusticia mea z a delicto meo munda me qa tibi soli pecaui. Complaceat expectans exp

Fig. 54 ◁
**A Bagpiper, a Goat, and Two Men
in an Absurd Joust**
[Saint Martin Dividing His Cloak]
Lieven van Lathem
Prayer Book of Charles the Bold
Ghent and Antwerp, 1469
JPGM, Ms. 37, fol. 34v

The silliness of the pretend joust at the
bottom of this page contrasts with the
seriousness of the miniature, in which
Saint Martin cuts off a section of his
elegant red robe for a poor, crippled man.
Astride a goat and a ram, with their feet
practically touching the ground, the two
erstwhile knights, "protected" by an armor
of baskets, go at one another with roasting
spits. Of special note are the winnowing
baskets that they use as shields, as we have
seen these already, correctly employed in
an earlier manuscript (fig. 25).

Fig. 55 △
Mice Strike Back
Book of hours
England, ca. 1320–30
BL, Harley Ms. 6563, fols. 71v–72

These two scenes belong to a unique series,
drawn over several consecutive pages, in
which mice strike back at their most deadly
enemy. When they are foiled in their direct
assault on the cat's castle (right page), they
bring out a heavy-duty siege engine. On the
left page, a mouse prepares to discharge
a trebuchet (a kind of medieval catapult),
which is aimed directly at the castle.

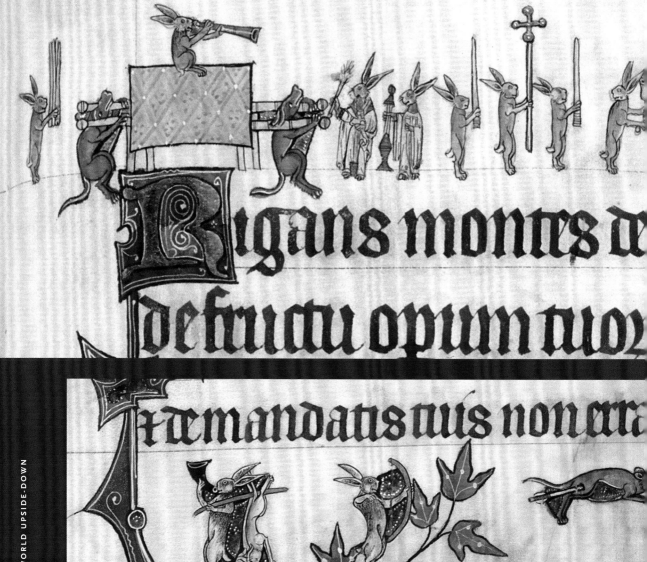

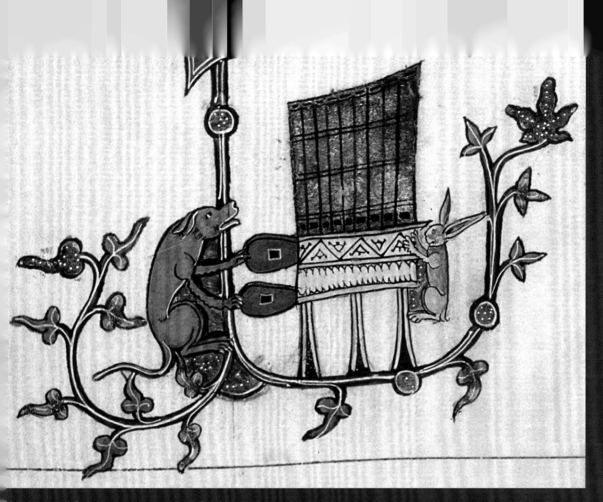

Fig. 56 ◁ (top left)
A Rabbit Funeral
Gorleston Psalter
England, ca. 1320
BL, Add. Ms. 49622, fol. 133

Fig. 57 ◁
Rabbits Strike Back
BL, Add. Ms. 49622, fol. 16v

Fig. 58 △
A Hound and a Rabbit Playing an Organ
BL, Add. Ms. 49622, fol. 116v

Here is an example of topsy-turvy marginalia having both a comic purpose and personal meaning. The Gorleston Psalter was made around 1320 for an important English baron, John of Warenne. He clearly appreciated the pun (rabbit warren/Warenne) represented in the borders of his manuscript, where rabbits and warrens abound. Here, the rabbits have pressed their enemies into service as pallbearers in an elaborate funeral procession, presumably for one of their kin (fig. 56). In the most direct reversal of roles, two rabbits are hunting down hounds (fig. 57). In a third and unusually optimistic example, a dog and a rabbit now cooperate to make music from an upright organ—a strange harmony indeed (fig. 58).

MAKING CONNECTIONS

While there might not have been hard and fast rules that governed the placement and subjects of marginalia, there are enough examples of identifiable connections between the text and illustrations, on the one side, and the marginalia, on the other, to suggest that the immediate context did often play a significant role in the way the illuminators thought of the area at the edge of the page. Among these examples we can find simple and direct relationships, such as the donkey singing in response to adjacent musical notation (fig. 1), or episodes from the life of Saint Catherine expanding upon an illustration for the prayer devoted to her (fig. 69). There are also more complicated and indirect relationships that rely on the use of metaphor and other symbolism, as in the Italian Bible in which a young man carrying the "weight" of the decorated initial corresponds to the burdens mentioned in the nearby text (fig. 62). Marginalia certainly functioned as entertainment, but these examples suggest that artists also thought of them as an opportunity to enrich the reader's experience, by making meaningful connections from text to image, or image to image, and back again across the page.

Fig. 59 ▷
Detail of **A Rowboat Pulled by Two Men** (fig. 66).

ra: oxbem ter
u fundasti. a
sti.

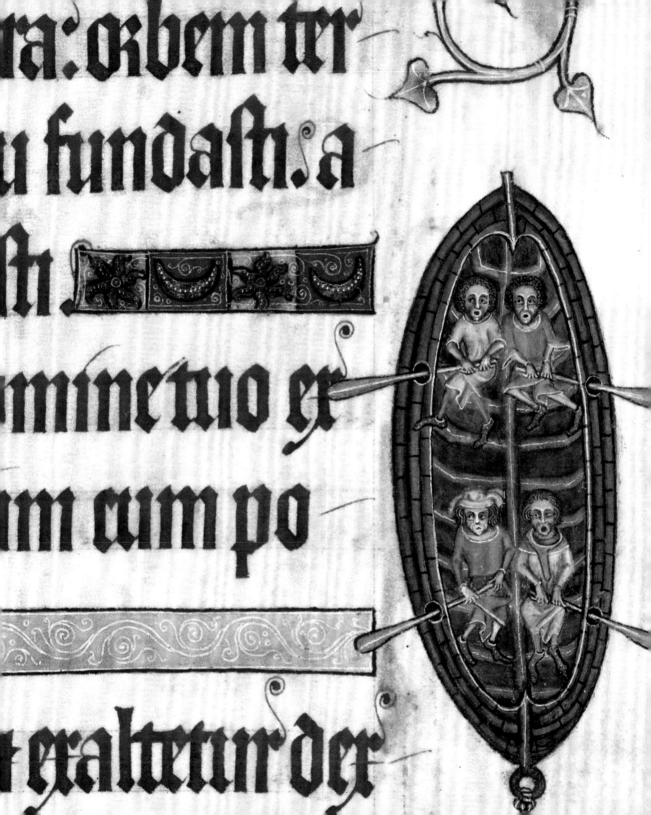

mine tuo ex

m cum po

exalretur der

VERBAL CLUES

Illuminators relied on a number of sources for marginalia, the most immediate being the text at the center of their work. Sometimes marginalia referred directly to content (fig. 60). In other instances, the images made oblique or symbolic reference to either specific words or passages, and became a kind of game through which the reader's attention was directed back to key themes in the text (figs. 62–66). Common to all the examples in this section is that what you see in the margins corresponds in some way to the words on the same page.

Fig. 60 ◁ ▽

Animals Using Astronomical Instruments
[Initial *Q*: Students Receiving an Astronomy
Lesson]
Ptolemy, *Almagest*
Northern France, ca. 1309–16
BL, Burney Ms. 275, fol. 390v

In the *Almagest* (Latin form of the Arabic for "great book"), the only comprehensive treatise on astronomy to survive from antiquity, Ptolemy (A.D. 85–165) described the earth as the center of our cosmos, a belief that held well into the sixteenth century. In the Initial *Q* that introduces this fourteenth-century copy of the text, a female personification of astronomy is pointing to the stars. The animals in the lower margins of the same page demonstrate the practical tools of the trade: a monkey with a pillar sundial, a fox with the celestial globe, a goat with an astrolabe, and a bear and a ram using a sextant.

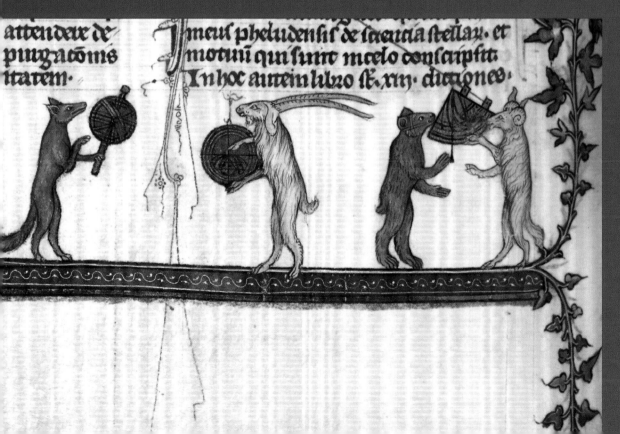

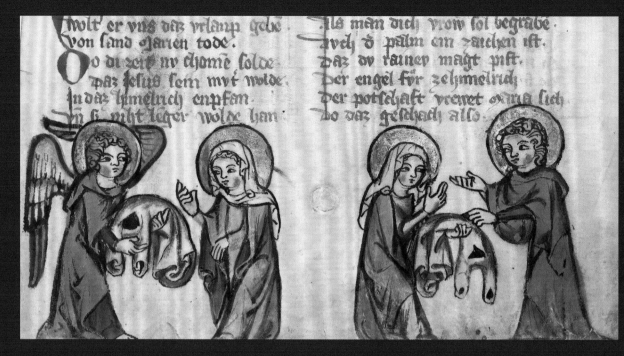

Fig. 61 △
**An Angel Presents Christ's Burial
Shroud to the Virgin; The Virgin Shows
the Shroud to Saint John**
Leaf from Brother Philip, *The Life of the Virgin*
Germany (Bavaria), ca. 1330–50
JPGM, Ms. Ludwig XIII 2, recto

The scene in the lower margin of this page
would have helped to highlight the human
qualities of the Virgin that are described
in the adjacent text. It is part of a lengthy
devotional poem, written in German,
that included biblical events and other
episodes from popular legends. To the left,
Mary receives Christ's tunic, which she
then shows to the disciple John as proof of
Christ's ascent into heaven.

Fig. 62 ▷
**A Trumpeter, a Dragon, a Bird, and
a Kneeling Man**
[Initial *E*: A Monk with a Book; Initial *P*: Saint Paul
Giving a Letter to a Messenger]
Bible
Bologna, ca. 1265–80
JPGM, Ms. Ludwig I 11, fol. 499

Here is an example of marginalia highlighting
a specific passage in the nearby text. The
decorated stem of the letter *P* is supported by
a young man, who bends under its imaginary
weight, evoking the phrase found in Latin in
the left column: "Bear one another's burdens;
and so you will fulfill the laws of Christ" (4–6
lines from the bottom). In addition to the
burdensome letter, the man is tormented by a
dragon and a bird. The dragon is often used as a
symbol of evil in Gothic marginalia, and in this
context, it suggests that the man's real troubles
are of a moral nature.

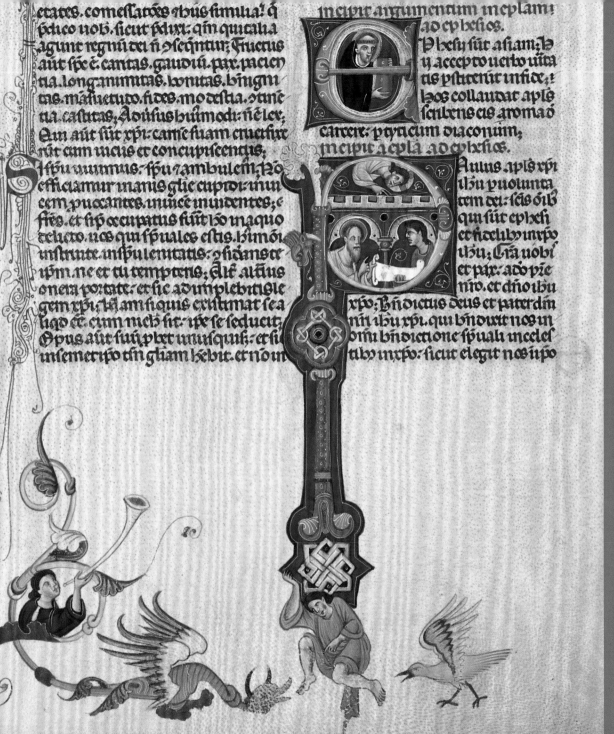

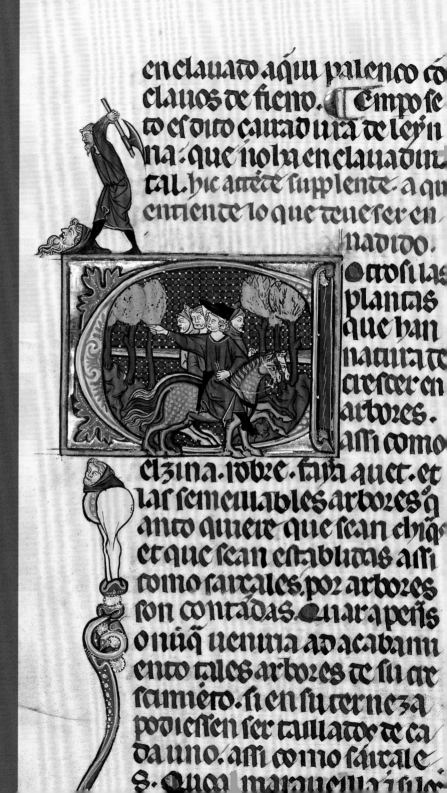

Fig. 63 ▷
A Man Wielding an Ax
[Initial *E*: Riders on Horseback]
Feudal Customs of Aragon
Northeastern Spain, ca. 1290–1310
JPGM, Ms. Ludwig XIV 6, fol. 145v

The threatening figure of a man
wielding an ax in this margin
is partly explained by the text,
a prohibition against cutting
young trees.

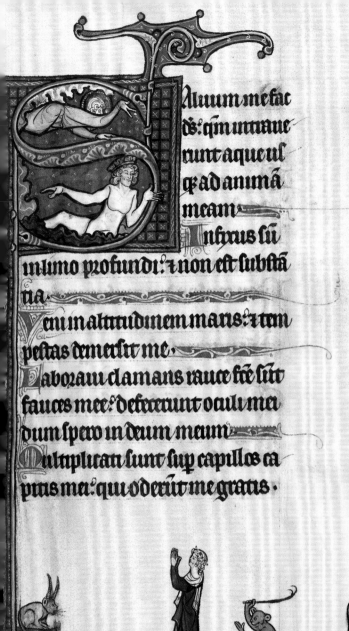

Fig. 64 ◁
A Devout Noblewoman Menaced by Demons
[Initial *S*: The Lord Appearing to David in the Water]
Bute Master
Bute Psalter
Northeastern France, ca. 1270–80
JPGM, Ms. 46, fol. 92

In this *bas-de-page*, a woman suffers from the torments of demons, one attacking her from behind with a hooked fork as she raises her hands to pray for deliverance. In this action she is connected to both the text—"Save me, O God, for the waters come in even unto my soul" (Psalm 68)—and the large historiated initial *S*, in which the text's author, King David, prays for his own rescue from the consuming waters—a metaphor for enemies, both real and spiritual.

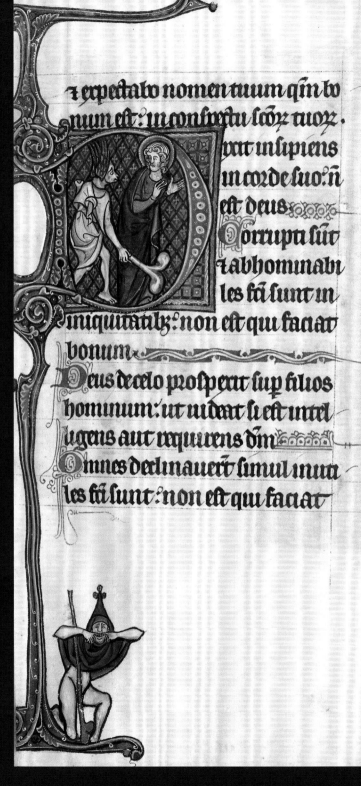

Fig. 65 ▷
A Fool Grimacing at the Reader
[Initial *D*: The Fool Menacing Christ]
Bute Master
Bute Psalter
Northeastern France, ca. 1270–80
JPGM, Ms. 46, fol. 72

The fool who looks out from the
bottom of this page relates to both
the "fool" in Psalm 52 ("The Fool
said in his heart, 'There is no God'")
and to a second fool in the historiated
initial *D* on the same page, who is
tormenting Christ.

Fig. 66 ▷
**A Rowboat Pulled by Two Men
and a Large Snail**
Luttrell Psalter
England, ca. 1330–45
BL, Add. Ms. 42130, fol. 159v

Sometimes reference to the nearby text can help to explain something that otherwise looks absurd in the margins. Take this image of a boat being rowed with great effort in one direction, while two men on land pull it the other way. Although the adjacent Latin text (Psalm 88:12–14) mentions "sea," "arms," "might," and "strong hands," only if you rearrange them do you come up with a possible source for the improbable scene: "In the sea, men use the power of their arms." There is nothing in the text, however, to help explain the enormous snail!

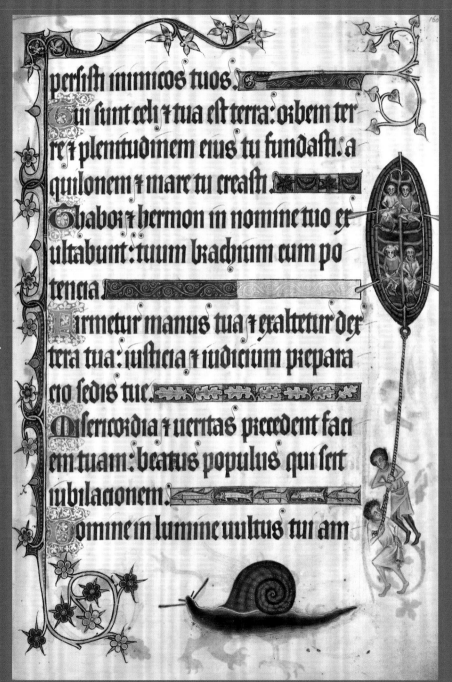

There are plenty of connections between marginalia and other images on the same page, such as historiated initials and miniatures. They serve as additional episodes from the same story (fig. 67), or as references to related stories (fig. 68). This was, however, less often the case with thirteenth- and fourteenth-century marginalia than with their successors, the elaborate, animated borders of the fifteenth century. There you are more likely to find several related scenes, either individually framed or interspersed among the dense, foliate decoration (fig. 69). For the illuminators of these later borders, the margins were seen as the ideal space to elaborate upon the story without detracting from the main subject of the miniature.

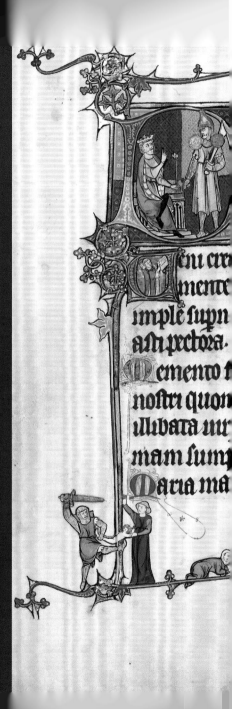

Fig. 67 ▷
The Massacre of the Innocents
[Initial *D*: Herod Ordering the Massacre of the Innocents]
Ruskin Hours
Northeastern France, ca. 1300
JPGM, Ms. Ludwig IX 3, fol. 85v

On this page, the lower margin becomes a convenient space for the expansion of the biblical story of the Massacre of the Innocents. In the large initial *D*, King Herod, having heard from the wise men that the King of the Jews has been born, directs a soldier to have all male babies in Bethlehem slain. We see the orders carried out in graphic images at the bottom of the page, where two frantic mothers are depicted under a line of text in which the Latin word *mater* (mother) occurs twice. These events are not recounted in the adjacent text, a prayer to the Virgin Mary, but belong to the series of episodes from the infancy of Christ that are traditionally found in devotional books such as this one

Fig. 68 ▷ ▽
Scenes from the History of the Dominican Order
[Initial *I*: Saint Dominic Enshrined]
Jacobellus of Salerno
Gradual
Bologna, ca. 1270
JPGM, Ms. Ludwig VI 1, fol. 38

This page contains a chant sung at the mass for the feast of Saint Dominic, founder of the order of preachers known as the Dominicans. Accordingly, in the upper left, the large letter *I* contains a portrait of the saint, while three key episodes from his life are presented in the lower margin by four winged friars and nuns. Given that the manuscript was made by a Dominican artist for the use of a convent of Dominican nuns, these narratives would have been especially meaningful for the intended audience.

Fig. 69 ▷
Scenes from the Life of Saint Catherine of Alexandria
[Saint Catherine Tended by Angels]
Spitz Master
Book of hours
Paris, ca. 1420
JPGM, Ms. 57, fol. 45v

The artist known as the Spitz Master used this border to expand the narrative scope of the miniature, which introduces a prayer to Saint Catherine of Alexandria. Infuriated by her refusal to worship pagan idols, the emperor Maxentius imprisoned Catherine without food or water for twelve days. She was comforted and fed, however, by angels sent from God, as seen in the central image. Three other events from Catherine's life frame the miniature: to the left, she debates the veracity of Christ's existence with pagan scholars; in the lower margin, she prays for the destruction of the wheel on which she was to be tortured; and finally, to the right, she is about to be beheaded, as two angels wait above to whisk her soul to heaven.

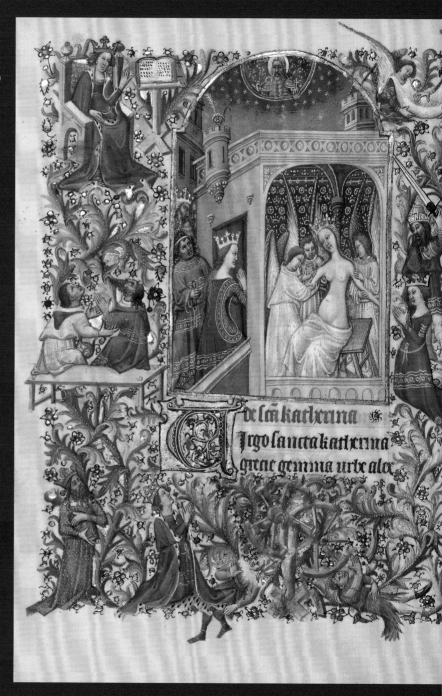

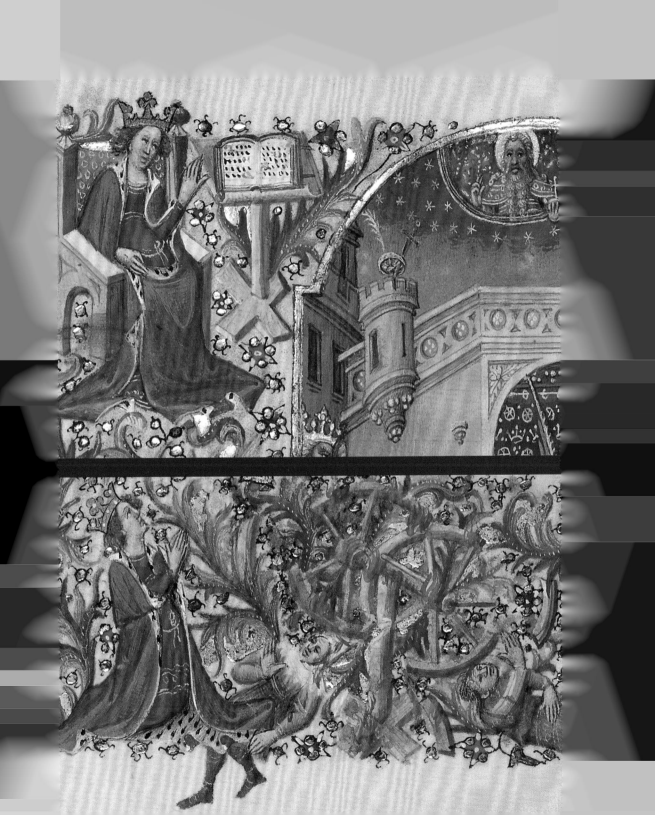

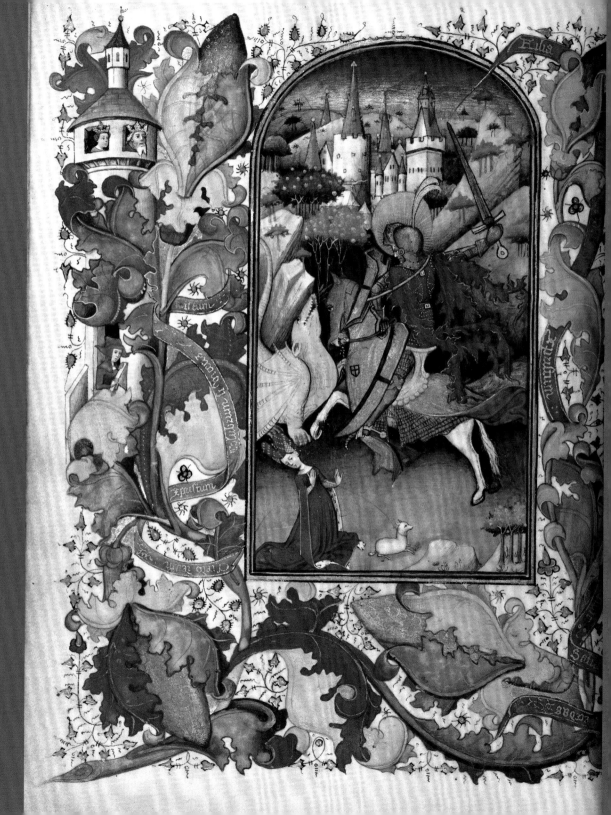

Book of hours
Probably Ghent, ca. 1450–55
JPGM, Ms. 2, fol. 18v

Although it is almost crowded off the page by the enormous stalks of foliage, the tiny tower at far left is integral to the story of Saint George and the dragon seen at the center of the page (the illustration to a prayer commemorating this Christian hero). A pagan king and queen, along with their maid, watch from the windows as George rescues their only daughter from the beast that had terrorized them and their subjects for years. In gratitude for their deliverance, the whole kingdom converted to Christianity.

Fig. 71 ▷
David and Goliath with Hunting Scenes
[Initial *H*: David Playing the Harp]
Book of hours
Northern Netherlands, after 1460
JPGM, Ms. Ludwig IX 9, fol. 75

In this Dutch book of hours, we see a simple example of the interaction between the border and the primary illustration. In the initial *H* is a portrait of the author, King David, introducing the text of the penitential psalms (which ask for God's forgiveness). And in the margin we see one of the most memorable episodes from the life of David—his defeat of the giant Goliath.

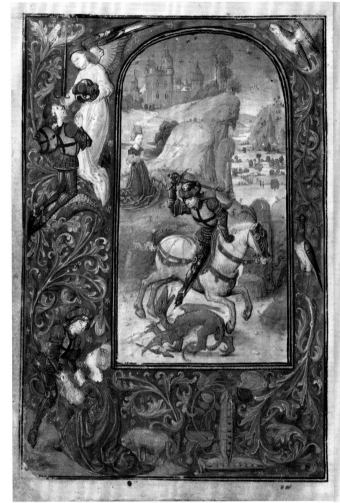

Fig. 72 △
**Scenes from the Life of Saint George;
An Angel Musician and Birds**
[Saint George and the Dragon; Charles
the Bold Presented by an Angel]
fols. 67v–68

That this prayer book held special
meaning for Charles the Bold is indicated
by the inclusion of no fewer than three
portraits of the duke. Here he is shown
in prayer opposite a miniature of Saint
George slaying the dragon. As in the Saint
Catherine page seen elsewhere (fig. 69),
there are additional scenes from the life

of the saint integrated into the border:
the saint receiving his sword and helmet
from an angel (which also connects to
the portrait, in which Charles has the
protection of an angel), and the princess
kneeling to thank George for deliverance
from the dragon.

What's the Story in the Margins? Unfolding Narratives

A masterly use of the margins to "expand the story" of the central miniatures can be seen in this tiny prayer book made for Charles the Bold, the Duke of Burgundy (1433–1477) in the fifteenth century. Some borders were designed to complement the miniature by adding related narrative material, while others incorporated episodes and single motifs that offered symbolic counterparts to the subject of the main illustration. This arrangement is still very much in line with the treatment of earlier medieval illumination, even if the actual painting technique has been transformed. While vast unified worlds unfold to distant horizons in miniatures reflecting the most recent innovations in Northern Renaissance painting, in the borders you still see isolated figures and small, silhouetted scenes. While the selections here were chosen to highlight the different kinds of meaningful relationships between the main images and the borders, equally enchanting are the variations on individual subjects from medieval marginalia pictured in the earlier parts of this book, including threats from dragons (fig. 22), observations of nature (fig. 43), topsy-turvy topics (fig. 54), and absurdly composed hybrid creatures (see fig. 49).

Prayer Book of Charles the Bold
Lieven van Lathem and Workshop
Ghent and Antwerp, 1469 and ca. 1471
JPGM. Ms. 37

Fig. 73 ◁
Salome Tormented by a Devil and Cain Murdering Abel
[The Beheading of Saint John the Baptist]
fol. 17

The scenes in this border relate, in one case directly, and in the other case, symbolically, to the depiction of Saint John the Baptist's martyrdom in the miniature. The woman to the right being tormented by the devil is Salome, wearing the same striking red headdress and blue gown as in the miniature, where she waits with her platter for the head of Saint John—her macabre reward, according to the Bible, for dancing for her step-father, King Herod. The devil is never mentioned in the biblical account, but by pairing him with Salome in the border, the artist has suggested that for her sinful behavior Salome would be justly punished. In the lower border John's beheading is equated with the biblical prototype for all unjust executions—Cain's murder of Abel.

The pelican, which you see in the upper right of this border, served as a symbol for the sacrifice of Christ, which would have been immediately understood by the medieval reader even if unfamiliar to a modern one. According to medieval animal lore, so feisty were young pelicans, that their parents struck them dead. After three days the loving and repentant mother pelican would tear at her breast and drench her offspring with her blood, which was said to revive them. Paired with the portrait of Saint John the Evangelist, this motif underscores the evangelist's role as direct witness to the Crucifixion of Christ, and specifically to the spilling of Christ's blood for the salvation of mankind. The attack on the lion at the bottom of the page is a related metaphor for the Mocking of Christ (for whom the lion was a symbol) that preceded the Crucifixion.

Fig. 75 ▷ ▽
Jonah Cast into the Mouth of the Whale
[The Entombment]
fol. 119v

In the margin of this page, we see the Old Testament episode of Jonah being thrown into the mouth of the whale. Medieval theologians understood this event as a foreshadowing of Christ's Entombment, which is represented in the miniature on the same page. Since Jonah's escape from the whale happened after three days and three nights, the event was believed to foretell the Resurrection, which also took place three days and nights after Christ's entombment. Accordingly, this page introduces the final section in the Hours of the Passion, a collection of prayers that were recited in memory of the torments suffered by Jesus.

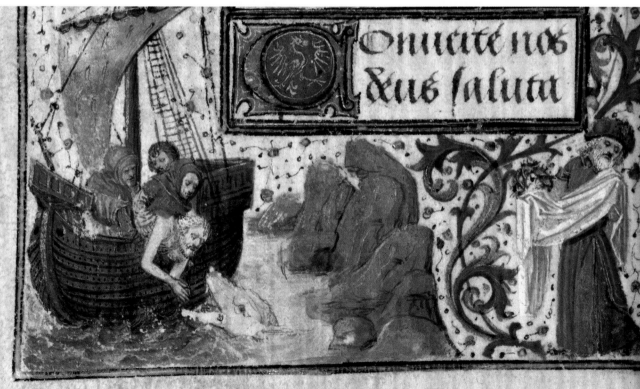

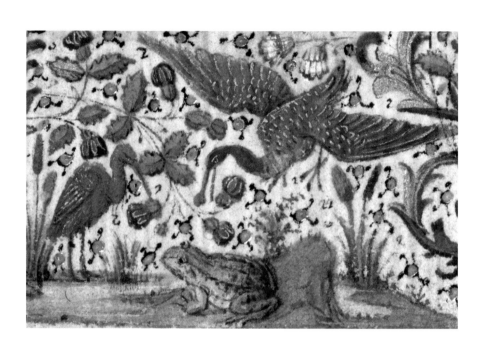

SUGGESTIONS FOR FURTHER READING

Michael Camille, *The Gargoyles of Notre Dame: Medievalism and the Monsters of Modernity* (Chicago, 2009).

Michael Camille, *Image on the Edge: The Margins of Medieval Art* (Cambridge, MA, 1992).

Michael Camille, *Mirror in Parchment: The Luttrell Psalter and the Making of Medieval England* (Chicago, 1998).

Christa Grössinger, *The World Upside-Down: English Misericords* (London, 1997).

Margot M. Nishimura and David Nishimura, "Rabbits, Warrens, and Warenne: The Patronage of the Gorleston Psalter," in *Studies in Manuscript Illumination: A Tribute to Lucy Freeman Sandler*, eds. Carol Krinsky and Kathryn A. Smith (London, 2008), pp. 205–18.

Stella Panayotova, *The Macclesfield Psalter* (New York, 2008).

Lilian M. C. Randall, "Exempla as a Source of Gothic Marginal Illumination," *Art Bulletin* 39 (1957), pp. 97–107.

Lilian M. C. Randall, *Images in the Margins of Gothic Manuscripts* (Berkeley, 1966).

Lucy Freeman Sandler, "The Word in the Text and the Image in the Margin: The Case of the Luttrell Psalter," *Journal of the Walters Art Gallery (Essays in Honor of Lilian M. C. Randall)* 54 (1996), pp. 87–99.

Lucy Freeman Sandler, "The Study of Marginal Imagery: Past, Present, and Future," *Studies in Iconography* 18 (1997), pp. 1–49.

THE MEDIEVAL IMAGINATION SERIES

The Medieval Imagination Series focuses on particular themes or subjects as represented in manuscript illuminations from the Middle Ages and the early Renaissance. Drawing upon the collections of the J. Paul Getty Museum and the British Library, the series provides an accessible and delightful introduction to the imagination of the medieval world. Future titles will cover architecture and fashion, among other topics.

Other volumes in the series:

Beasts Factual and Fantastic
Elizabeth Morrison

Faces of Power and Piety
Erik Inglis

ABOUT THE AUTHOR

Margot McIlwain Nishimura teaches the history of manuscript illumination and medieval art at the Rhode Island School of Design. She was introduced to the study of medieval and Renaissance manuscripts as an undergraduate intern in the Department of Manuscripts at the J. Paul Getty Museum in 1985. She graduated from Smith College and earned her doctorate in the History of Art from the Institute of Fine Arts, New York University. Her research and publications have focused on English Gothic Psalters, marginalia in all medieval media, a tenth-century Frankish Gospel Book, and the Grey Collection of illuminated manuscripts in the National Library of South Africa in Cape Town.

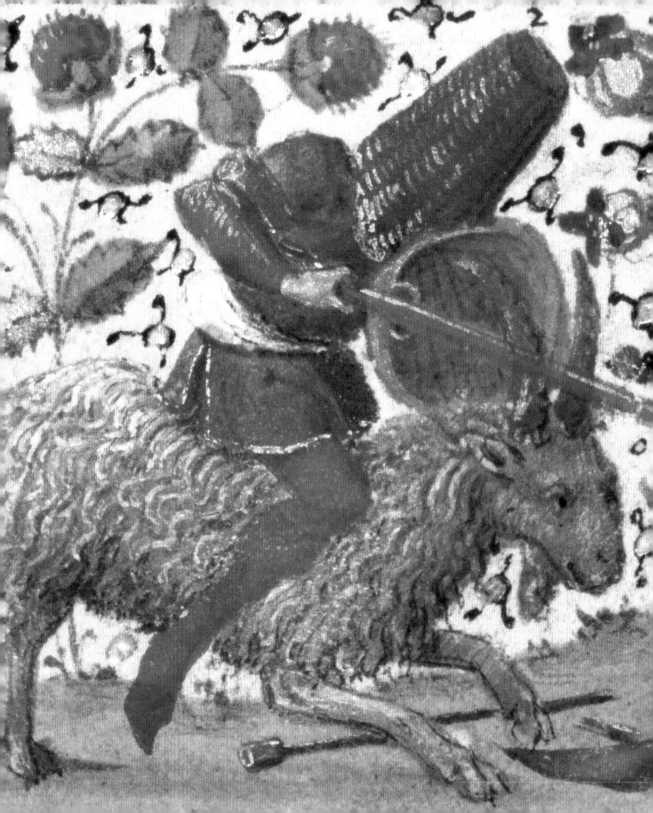